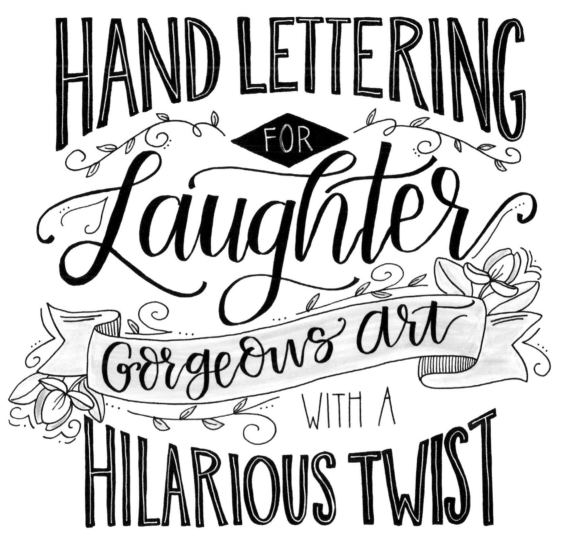

HAND LETTERING

FOR

Laughter

Gorgeous Art

WITH A

HILARIOUS TWIST

Amy Latta AUTHOR OF HAND LETTERING FOR RELAXATION

PAGE STREET
PUBLISHING CO.

PAGE STREET
PUBLISHING CO.

First published in 2019 by
Page Street Publishing Co.
27 Congress Street, Suite 105
Salem, MA 01970
www.pagestreetpublishing.com

Distributed by Macmillan, sales in Canada by The Canadian Manda Group.

23 22 21 20 19 1 2 3 4 5

ISBN-13: 978-1-62414-731-9
ISBN-10: 1-62414-731-3

Library of Congress Control Number: 2018958701

Cover and book design by Meg Baskis for Page Street Publishing Co.
Illustrations by Amy Latta
Cover image © Amy Latta

Printed and bound in China

FOR MY DAD, WHO
CAN FIND HUMOR IN
ANY SITUATION, AND
MY MOM, WHO TAUGHT
ME TO MAKE THINGS
BEAUTIFUL.

CONTENTS

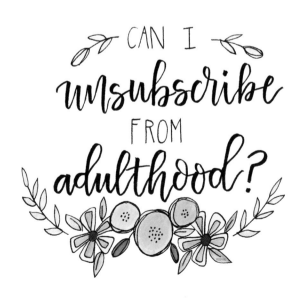

INTRODUCTION

I don't know about you, friend, but I love to laugh. Let's face it: everyday life can be a struggle sometimes, not to mention the fact that we live in a world where it seems like every day there's some sort of bad news. It's easy to get discouraged and let those things weigh us down, or we can choose to look for joy instead. There are blessings and beautiful things all around us, and there's no better weapon against a bad day than a good sense of humor. Will you join me in an adventure to spread some laughter and creativity?

The book you hold in your hands combines two of my very favorite things—humor and hand lettering—and it's designed to help you do the same. As you work through the chapters, you'll be learning all kinds of hand lettered fonts, embellishments and techniques so that you can create your own fabulous works of art. At the end of each chapter, you'll be creating a lettered design featuring a quote that I hope will make you smile. (Make sure you don't have a mouthful of coffee, because I can't guarantee it won't come out your nose.) After each tutorial, there's a special page with a hand-drawn border to color and blank space in the center where you can create your masterpiece, using my sample design as inspiration. Feel free to letter on other surfaces too, like a sketchbook, canvas or anything else you like. In fact, you'll find a section full of ideas in the back of the book to get you thinking about other places and surfaces for using your new skills.

Whether you're a total beginner or a lettering pro, you'll be walking away from this book with plenty of new techniques and 40 fabulous pieces of hand lettered art. My hope is that not only will you enjoy them, but you'll also find ways to share them with others and spread the laughter. These designs are perfect for framing and displaying in your home, hanging on a bulletin board at work or creating a card for a friend. After all, joy is better when it's shared! What do you say? Are you ready to get started? Let's do this!

Amy Latta

SUPPLIES

You wouldn't go golfing without a proper set of clubs or take up ballet lessons in jeans and sneakers. To get the right results in any hobby, you need the proper tools. When you're just starting out with lettering, you can certainly use whatever pens or markers you have available, but as you continue, you'll want to get a few specific tools that are designed for the job. I get questions almost every day about what supplies I personally recommend and why, so I want to take a few minutes before we get started to give you my advice on what you'll need. First, here's a very general list of things you'll want to have handy.

FOR DRAWING AND LETTERING

Pencil
Eraser
Ruler or other straightedge
Fine-point markers
Medium-weight (65- to 75-lb) sketch paper
Brush-tip marker/pen (for brush lettering technique)
White gel pen

FOR WATERCOLORING

Aqua pen
Water-based markers
Hot press watercolor paper

FOR LETTERING ON NON-PAPER SURFACES

Paint pens/markers
Chalk markers

Now that you have a basic list of what you'll need, let's talk in a little more detail about some of these supplies.

PENCILS

There are all kinds of special drawing pencils out there, as well as your regular HB school pencils. Any type of pencil will work to do your preliminary sketching, but a helpful tip is that the softer the pencil, the easier the lines will be to erase. If you can get your hands on a 2B pencil, it's ideal for the job. However, I confess that more often than not, I just use whatever my boys have left lying on the table after finishing their homework.

ERASERS

Do you have a favorite eraser? It might sound strange, but I definitely do! There are few things in my supply chest that I love more than my Tombow Mono Eraser. Have you ever used a pencil with a bad eraser that made more of a mess on your paper when you used it than if you'd just left the mistake alone? Me too. I hate that. The Tombow Mono Eraser will make sure that never happens to your lettering designs. It will erase all your pencil marks from paper, wood, canvas and more, and you'll never know they were there. The plastic and NP Non-PVC ones are my favorite for regular everyday use, and the Dust Catch one is pretty cool if you're going to be doing a lot of erasing because it eliminates most of the mess. If you need something with an extra punch, the Tombow Mono Sand Eraser can even erase ballpoint pen, colored pencil and some markers. I'm still looking for an eraser than can get rid of extra pounds. I'll keep you posted.

FINE-POINT MARKERS

Fine-point markers are great for outlining and for detailed drawings. They can also be used to write thin letters, like the Minimalist Print Font (page 14) and Stretched Script Font (page 84) we'll be learning. They come in a variety of different sizes and are usually labeled with a number

that represents how many millimeters thick the tip is. The smaller the number, the finer the line will be. The most common sizes are 01, 03 and 05. The 03 is what I use most often, but I use all three sizes for different illustrations and lettering styles. Tombow Mono Drawing Pens are my favorite, but I also like Sakura Micron Pens and Faber-Castell Drawing Pens. Unlike the others, the Faber-Castell pens are labeled as XS, S and M rather than by millimeters. I understand. I don't want to display my measurements either.

BRUSH-TIP MARKERS

If you want to master the technique of brush script, you need the right tool for the job: a brush pen or brush-tip marker. What distinguishes this type of marker from a "regular" bullet-tip marker is that the tip is flexible and responds to pressure. When you apply pressure, the tip bends and produces a thick, dark line. When you release that pressure, you'll get a thinner line. Controlling this allows you to create a contrast between thick and thin lines in your writing, which gives you that well-known hand lettered look.

My all-time favorite brush-tip pen is the Tombow Fudenosuke. It's available in both soft and hard tip; both are flexible, but the soft tip is easier to control. The soft tip is my personal favorite and definitely what I recommend for beginners. The Fudenosuke is now available in 10 colors: red, orange, yellow, green, blue, purple, pink, grey, brown and black. If you want a similar pen that has even more color options, you'll want to check out the Pentel Sign Pen with Brush Tip. It comes in a variety of colors and is a similar size and feel to the Fudenosuke. My other favorite brush marker is the Tombow Dual Brush Pen. This marker has a bullet tip on one end for "normal" writing, and a brush tip on the other end. These come in 96 colors, and the brush end works wonderfully for blending and coloring. I will be sharing a technique in chapter 6 using the Tombow Dual Brush Pen that allows you to fill in your designs with a gorgeous watercolor effect that doesn't require any paint. The brush tip on the Tombow Dual Brush Pen is significantly larger than that of the Fudenosuke and the Pentel Sign Pen, so it's ideal for larger projects.

GEL PENS

Gel pens are different from other types of markers and pens because the ink sits on the surface of your paper rather than going down into the fibers. This means that whatever you write or draw with the gel pen will sit on top of any coloring or lettering you've already done, which is perfect for adding highlights. It allows you to use white and light or metallic colors on top of darker colors for accents and negative space designs. I personally use the Sakura Gelly Roll, but you can choose your favorite kind. And now I want a jelly roll.

MEDIUM-WEIGHT SKETCH PAPER

As you work through *Hand Lettering for Laughter*, I encourage you to letter and draw right here in the book. I, along with the wonderful folks at Page Street Publishing, worked very hard to choose the best possible specialty paper for you, so enjoy it! Of course, you might want extra space for practice, and you'll want to keep lettering long after you fill these pages. When that happens, you can use whatever paper you have handy, but I have definitely learned from experience that your results will look very different on sketch paper than on something you grab out of your printer. I prefer to letter on medium-weight sketch paper, which means you'll want to look for something labeled between 65 and 75 lb. This weight should keep your marker from bleeding through and give you both a practice surface and a piece of art you could frame and display. I hate ordering my sketchbooks online because the other thing I need to know is how smooth the paper is. When it comes to lettering, smoother is always better, so I like to physically feel the pages and choose the best one. If you ever spot me in a craft store opening up all the sketchbooks and touching everything, now you'll know why! Also, please say hi and we can go grab a coffee.

AQUA PENS

An aqua pen is just what it sounds like: a pen that holds water. It has a tip like a paintbrush and a hollow barrel that you can unscrew and fill with clean, room-temperature water. Once it is filled, you can use an aqua pen for blending, watercoloring and even lettering. I'll share all the details for how that works later in the book. These pens come with different sized tips, so you can choose the best one for your project. My favorites are the Pentel Aquash and the FolkArt Water Brush Set. They are easy to use and can be refilled over and over. Aqua pens can be used with water-based markers as well as traditional watercolor paints. They can also be used to amuse and taunt your cat.

HOT PRESS WATERCOLOR PAPER

When you're creating the featured designs in this book, including those with watercolor, you can do your artwork right here on the special provided pages. You might also decide, though, that you want to recreate a design for a friend or for yourself to frame and put on display. If you're doing something that incorporates the No-Paint Watercolor Technique (page 30), you'll want to use watercolor paper, which is specially designed to withstand getting wet while preserving the quality of your artwork.

There are two different types of watercolor paper: cold press and hot press. Cold press is the more common type, and what you're most likely to see just labeled "watercolor paper." It has a visibly uneven texture, and if you run your hand over it, you'll feel that it's not smooth. This isn't ideal for lettering projects because the uneven spots can snag your pen and cause your letters to look shaky. Instead, you want to look for paper that's specifically labeled "hot press." This will be very smooth to the touch and will look a lot like cardstock. It's the perfect paper for the type of project you'll be creating and is what I use when I teach workshops. I have bought the Fabriano Studio 9 x 12–inch (23 x 33–cm) Watercolor Paper Pad so many times I think Amazon should rename it after me.

PAINT PENS/MARKERS

If you decide to letter on surfaces other than paper, your water-based markers are no longer going to do the job. For most surfaces, like wood, terra-cotta, metal, plastic and more, the best option is a paint pen. These come in many colors and with different sized tips. However, these do not have a brush tip, so you won't be able to do brush lettering. Instead, you'll have to rely on Faux Calligraphy (page 10) if you want a brush script look. I regularly use a variety of paint pens, including Sharpie, Elmer's Painters and Marvy Uchida. They all work the same way and I've had great results with all three brands. These do contain actual paint, so be aware of that when it comes to getting them on your kitchen table and your cat's tail. I hear that can make your husband grumpy.

CHALK MARKERS

If you want a chalkboard effect for your project, but you intend for it to be a permanent design, one option is to simply use a white paint pen. However, if you want the look and feel of chalk, you'll want to consider a chalk marker. Some are permanent, while others promise to be erasable. I have found, though, that even those that erase still leave ghosting marks and you can see where the letters were. If you truly want something to erase completely, the best option is going to be real chalk. If you want something more permanent and easier to work with, I recommend checking out Kassa Liquid Chalk Markers, American Crafts Erasable Chalk Markers or Marvy Uchida Bistro Chalk Markers. All of these write nicely and create a pretty finished product; however, be aware that they can smear if touched by well-meaning but accident-prone little boys, even long after the design is finished.

All of these supplies can be found at local craft stores as well as online. For more of my recommendations as well as specific links to these products, check out my Amazon Store Page at www.amazon.com/shop/amylattacreations.

NICE I'S

Writing in Faux Calligraphy

you have nice "i's"

Chances are, when you think of hand lettering, there's a particular style of writing that comes to mind. Brush script, that pretty cursive with a mixture of thick and thin lines that you see everywhere, has become the poster child for hand lettered art. It's the style that really took off and gained popularity, getting people excited about writing by hand again instead of doing everything digitally. There's a technique involved in creating brush script, and frankly it takes a good bit of time and practice to master. We'll look at that in more detail later on in this book, but because we want to hit the ground running, we're going to start with a super-simple way to achieve the same look without mastering brush lettering. Basically, we're going to fake it till we make it. I call this Faux Calligraphy, and you can do it on any surface with just about any pencil, pen, marker, chalk or other writing implement you can find.

If you've tried your hand at lettering before, this may already be a familiar technique to you. It's the first thing I teach when I lead workshops, and it's the first thing I cover in both of my other books as well, because it's such an important foundational skill. Even if you know how to do Faux Calligraphy already, you can use today's lesson as a refresher or a warm-up before we dive into some new material. Grab yourself a writing implement and let's get started!

"YOU HAVE 'NICE I'S.'"

I've been complimented on various things over the years, like my smile, my hair and my singing voice. My personal favorite, though, was one time in our dating days when my husband and I were walking through the mall and I jokingly pointed out what I'm still convinced was the world's ugliest shirt hanging in a window display. I decided to test him a little by asking, "What would you say to me if I wore that top?" Without missing a beat, he replied, "I'd compliment your pants." That just might be the moment when I really knew he was a keeper. Today, though, I'm going to give a compliment to you as we start this lettering journey together . . . "nice I's." You might be rolling your "e-y-e-s" at the pun, but seriously, y'all, what could be a more perfect quote to start off a hand lettering book than one that talks about your writing? We're going to learn a few basic skills, and then you'll be hand lettering it yourself on the border page at the end of the chapter. Take a look at my sample design, then let's dive in and learn how you can letter one just like it.

FAUX CALLIGRAPHY

Like I mentioned earlier, the most noticeable thing about this style of lettering is that it contains a combination of thick and thin lines. Every time you write, you are moving your pen either down toward yourself (this is called a downstroke), up away from yourself (an upstroke) or horizontally across the paper. The rule you need to memorize is as simple as this: downstrokes are thick while upstrokes and horizontal strokes are thin. If you can remember that, you'll always know where your letters should be thick instead of thin. With that in mind, here's how we take a word and make it look like it was written in brush script. This skill will actually come in handy even long after you master Simple Brush Technique (page 98), because there will be times when a brush pen won't work on your surface of choice, or may not be readily available.

STEP 1

To begin, write the word in cursive, leaving a little bit more space in between the letters than you normally would.

We're going to start with the word "you" because it's short and simple, and it's part of the design you'll be creating at the end of the chapter.

STEP 2

Identify all of the downstrokes in your letters and draw a second line in those areas.

The second line should be parallel to the original downstroke with a bit of space in between.

STEP 3

Color in the space between the lines.

This will give the appearance of a thicker line or stroke.

That's all there is to it! Once all of the downstrokes are thickened and colored in, your word will look just like it was written in brush script. See?

You can do this with any word you write; all you have to do is figure out where the downstrokes are for each letter. Here is a sample alphabet to help you. Although I might form some of my letters differently than you do, looking at them will give you an idea of which lines should be thick and which ones stay thin.

Another fun way to use Faux Calligraphy is by following the first two steps, then using a different color to fill in the spaces in step 3.

you

Faux Calligraphy can be done with whatever markers or pens you have, as well as pencils, chalk and paint pens. In fact, because paint pens and chalk don't have a brush tip, this is the only way to achieve the brush-lettered look on many kinds of projects. Take some time to practice in the space to the right. Focus first on the words in our quote design, but you can also play around with your name and any other words you'd like to try. "Joy" and "love" are good practice words because they're short and sweet.

When you're ready to try creating the featured hand lettered design for this chapter, head on over to the bordered page and use this technique to write "You have nice I's." You may want to start by using a pencil and a straightedge to lightly sketch a few horizontal guidelines on the page to help you keep the lettering straight. Then, use your favorite marker or pen to write the quote in Faux Calligraphy. When you're finished, erase any pencil lines you can still see, and feel free to color in the border to finish off your masterpiece.

CARPE DIEM TOMORROW

Minimalist Print Font

CARPE DIEM TOMORROW (hand lettered)

Peanut butter and jelly. Milk and cookies. Nutella and a spoon. Some things just go together. It works that way in design, too. A simple print and a fancy script make the perfect pair. Combining more than one style of writing within a design helps add visual interest to your work, and it also allows you to emphasize certain words within a quote. The next step in our lettering journey is to learn a basic print font that you can pair with the Faux Calligraphy script (page 10). It's called Minimalist Print, and it has a simple, farmhouse chic vibe that complements your script lettering perfectly. Let's take a look.

"CARPE DIEM TOMORROW."

There's so much we can do, friends, if we put our minds to it! The world is full of infinite possibilities. But do you wanna know a secret? Sometimes seizing the day is overrated. Dreaming big and achieving goals is fantastic, but so is wrapping myself up in my fuzzy blanket like a human burrito and cuddling my cat. I don't know about you, but I think today is the perfect day for a nap and maybe reading a good book . . . oh, look! You already have one in your hands! Let's give each other permission to relax. We'll still seize the day. Tomorrow.

MINIMALIST PRINT FONT

Many artists live by the motto, "Learn the rules like a pro so you can break them like an artist." To create this font, we have to do a bit of rule breaking. I know I've got your attention now! Let's talk first about what the "rules" of handwriting are. When we write, whether we're using lined paper or not, there is a set of invisible guidelines that we follow. The baseline is where the bottom of each of our letters sits. The cap height marks how high the tops of our capital letters go. The descender line is where the tails of letters like "p" or "j" travel below the baseline. Finally, the x-height marks where lowercase capital letters stop and where we cross letters like "A" and "H."

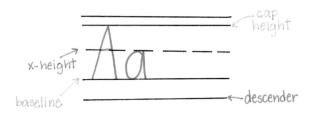

To achieve this Minimalist Print style, we have to break a rule . . . the x-height. Instead of crossing letters like "A," "E," "H" and "F" at a normal x-height, we're going to push the crossbar up toward the top of the letter. The same thing goes for letters that have lines touching or intersecting at x-height, like "R," "M," "P" and "B." The one exception to this is the "W," where we're going to use a lower than normal x-height instead. Take a look . . .

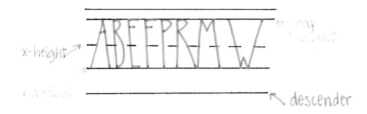

Here's a look at the whole alphabet written in this style.

ABCDEFGHIJKLM
NOPQRSTUVWX
YZ 0123456789

I've only provided an uppercase alphabet, because when I use this font, I typically only write in capital letters. It provides a nice contrast to my lowercase script. However, if you want to try a lowercase version, all you have to do is break the rules in the same way, raising the x-height line for things like the crossbar of the "t" and "f."

tf

You can write in this style using whatever writing instrument you like, including markers, pencils and chalk. Personally, I like my print letters to be very thin when I use this font, so I like to use 01 or 03 size drawing pens whenever possible. Take some time to practice writing a few words in the space provided. It can also be helpful to practice on lined paper so that you can see the guidelines as you work. Then, when you're ready, head over to the border page and create our quote design using a combination of this style and the Faux Calligraphy you learned in the last chapter.

To create the sample design, I started by tracing a semicircle in pencil and using that as a guideline for "carpe diem." I started by penciling in the position of the center letter, the final "e" in "carpe," then worked my way out to both sides. Next, I sketched a horizontal line below the semicircle and penciled in "tomorrow." Finally, I went over all my words with marker and erased the pencil lines. Now, it's your turn!

PRACTICE BELOW

MY HAPPY HOUR

Putting Bounce in Your Lettering

Remember how in the last chapter we learned to be rule breakers? We're going to be rebels again in this workshop, and we definitely have a cause: putting bounce in our lettering. As you've seen, you can certainly letter your words in nice, neat straight lines. But you've probably noticed that many of the lettering artists out there have a more whimsical style where their letters seem to bounce around at different heights within a word. It's actually easier than you think to do, and it will take your lettering to the next level. Plus, once you learn it, you don't have to worry as much about keeping your lettering perfectly straight. Ready to give it a try? Let's get started!

"NAPTIME IS MY HAPPY HOUR."

Everybody has something that gets them through the day. We all have responsibilities to carry out and work to do, but there's a light at the end of the tunnel. When we clock out, whether it's at 5 p.m. or a totally different time, we get to have our own "happy hour." We get to be off duty and to unwind doing whatever we like best. I'd like to say I look forward to doing really exciting, adventurous things, but I can't. What I want to do more than anything else is take a nap. Being a mom to two preteen boys is exhausting, and writing a book is, too. So is maintaining a website and social media and keeping the house in order and doing all the other things I do every day. I'm just plain tired. Give me a pillow, a blanket and my cat and I'm good to go. Walk away and don't let anyone say "mama" for at least sixty minutes. That's what I call a happy hour. What about you?

BOUNCE LETTERING

In the previous chapter, we talked about several guidelines that are in place when we write: Ascender height, descender height, cap height, x-height and the baseline. Typically, we form our letters within these guides, but when it comes to bounce lettering, everything changes. We have to let our ascenders go higher, our descenders go lower, and forget about keeping a consistent baseline. Take a look.

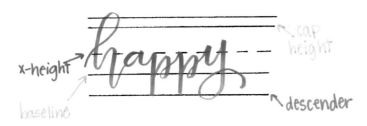

Once you understand that the trick to bounce lettering is forgetting about the constraints for where the high and low points of your letters go, it's a piece of cake, right? Well, not necessarily. For some artists, that's all they need to know, and they're off to their sketch pad to get started. If that's you, you can stop reading now and go play with your markers in the practice space. But if you're like me, you might still have an unanswered question, "HOW do I break the rules in a way that looks good?"

In other words, for me, it wasn't enough just to know that I could write my letters any place I wanted. When I tried, it looked willy-nilly and strange because I didn't have any method to my madness. *Essentially, I needed rules for how to break the rules.* Does that make sense? If you're in that boat, here are a few of the ways I tend to position my letters.

First, I've found that for letters that end with a downstroke, like "h," "l," "m," "n," "r" and "t," it feels and looks natural to extend that downstroke past the baseline before heading back up to form the next letter. These will become the lower points in your word.

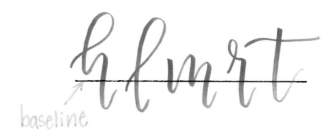

For letters with multiple x-height lines, vary the heights instead of making them all the same! For example, "m" and "w" take on a whole new look when written this way.

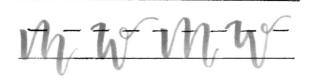

Balance out the rest of your word, making your remaining letters larger, higher, etc. Sometimes the best way to decide where a letter goes is by looking at what's right next to it. Play around with different ways to write your letters that break the normal constraints for where it should go.

happy

bounce

Make sense? No two artists create their bounce lettering in exactly the same way, and as funny as it seems to say, "there are no absolute rules other than to break the rules." As you practice, you'll start to develop a feel for how this works and it'll come more naturally to you. You'll get used to extending certain letters and shortening others. In the meantime, take some time to play around in the practice space with a few different words. Write them straight, then try adding some bounce and see what happens. If you get stuck, drawing a wavy line as your baseline and lettering on that can sometimes help.

Once you're ready, move on to illustrating our quote on the border page. My sample design uses a combination of Minimalist Print (page 14) and Faux Calligraphy (page 10) with bounce in the words "naptime," and "happy hour." To help balance the design visually, I also added a short horizontal line on either side of the centerline of text. Later in the book, we'll learn how to use all kinds of other embellishments, including more straight line techniques. Feel free to copy my design exactly or to put your own spin on it as you create your finished quote.

MONDAYS AND LEGOS

Mastering Basic Composition

One of the questions I'm asked on a regular basis is, "What's the trick to creating a great design?" You can master a million different fonts and embellishments, but you'll still struggle with lettering if you don't know how to make those different elements work well together. While all lettering artists have their own styles, there are some basic things most of us do when we design something. In this workshop, we're going to look at some simple tips and tricks to help you lay out a quote in a way that's visually appealing, and then we'll practice together.

"DEAR MONDAY, GO STEP ON A LEGO."

Have you ever been walking across the floor barefoot and accidentally stepped on a LEGO®? Since you and I are friends, I wish only the best for you, which means I hope your answer is a vehement *no*. If you have, though, you'll know it causes excruciating pain that I would only wish on a worst enemy. Like Monday. Mondays are just plain rude. I mean, there we all are, having fun and enjoying the weekend, and then who shows up? Monday morning. It knocks with the sound of an alarm going off and we have to do all kinds of things we don't want to do . . . starting with getting out of bed. There's lunch packing and child wrangling and working, plus we know there are five whole days before we get a weekend again. I'm sorry, Monday, I know it might sound cruel, but so are you. There's a LEGO over here with your name on it.

MASTERING BASIC COMPOSITION

Deciding on the composition for a quote can feel very overwhelming because it involves making a lot of different decisions! You're choosing how many fonts to use and which ones will best suit what you're lettering. You're also deciding on what, if any, colors to use, what embellishments and flourishes to add, and what size and shape you want your finished design to be. Plus, you'll need to think about how and where to divide your quote into separate lines. In this chapter, we're going to talk through a few of those basic decisions to help get you started.

STEP 1

Identify the essentials.

For me, the first step in coming up with a composition is to identify which of the words in a quote are most important and which ones are just filler. The important ones are what you'll want to emphasize by choosing a size and font that will stand out, while the others can be smaller and simpler so that they don't detract from the essential parts of the design. For example, in this quote, I'm going to choose to emphasize "Dear Monday," and "LEGO." I personally feel that of the fonts we've covered so far, Faux Calligraphy (page 10) packs more of a visual punch, so I'll use that for these important words.

STEP 2

Divide your quote.

Once you choose the main words, divide the quote into separate lines, so that the main words stand alone (or together, if they're part of a phrase like "Dear Monday") and the filler words have their own lines. In our example, it would look like this:

<div align="center">

Dear Monday,
Go step on a
LEGO

</div>

STEP 3

Sketch your guidelines.

Lightly sketch a series of horizontal lines on your page that correspond to the number of lines into which you divided your quote. I recommend using a pencil and a straightedge tool like a basic ruler for this step. Remember, these are very light lines—dark enough to see but easy to erase. Make sure you leave enough space between the lines to write. Then, draw a final line that goes vertically down the center of your guidelines to mark the center of your design. We're using straight lines for this design because they're the easiest for practice purposes, but one easy way to create visual interest in your composition is by adding a slight curve or an arch to some of your lines instead. You can also play around with diagonal lines, too! We'll go into this in more detail on advanced composition (page 34), where we'll be using all kinds of shapes inside our designs.

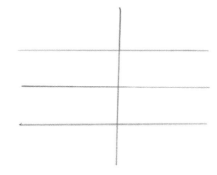

STEP 4

Start with your center letter for each line and sketch the word placement.

Unless you're deliberately skewing things for artistic purposes, you'll want your design to be centered. Here's my favorite way to do that: Count all the letters and spaces in each line and find the center. Starting there, work your way out to each side, positioning your letters.

STEP 5

Use your favorite markers and fonts to letter over your sketched placement.

You'll want to use large, dark and/or colorful letters for the main words. Black-and-white designs can have a lot of impact, but experiment with color, too! Sometimes, you'll find that certain colors tie in with your quote; for example, a quote about nature lends itself to greens and blues, while a coffee quote might look best with a bit of brown mixed in. Keep in mind that some colors naturally pair well together, like various shades of the same basic color or what we call complementary colors. The Tombow Blending Palette has a great color wheel on the back that can act as a guide, or you can easily find an image of a color wheel online for reference.

When it comes to fonts, based on what you know so far, you'll want to use Faux Calligraphy (page 10). The less essential words should be smaller and plainer, such as written with a fine-tip marker in Minimalist Print (page 14). If you already have some lettering background and know other fonts that would work well here, feel free to substitute them instead. Then, when your lettering is completely dry, go back and erase any pencil lines you still see.

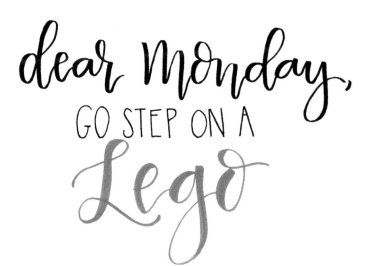

Remember, this is just one way to compose our quote. There are infinite possibilities, and while some will look better than others, there's no one "right" way to do it. Here are a few other quick examples of the same words lettered in different ways that still look great!

Now it's your turn! As you progress through the book and learn more fonts to add to your repertoire, you'll have lots more choices when it comes to choosing your styles. For now, though, we're going to use what you know and letter the quote in the practice space below, then on the border page. Feel free to choose other quotes you like and try this method of breaking them down, splitting up the lines and emphasizing the main words with larger, fancier lettering. You'll see—this composition thing is easier than you thought.

DEAR
monday,
GO
step on
A
Lego

DEAR MONDAY,
go step on
A LEGO...

DEAR
monday
GO step on
A LEGO...

PRACTICE BELOW

UNSUBSCRIBING FROM ADULTHOOD

Fancy Florals

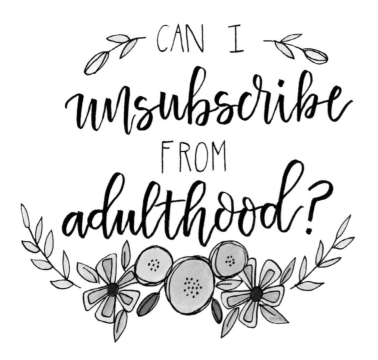

There are literally thousands of ways to embellish a hand lettered design, including everything from swirls and flourishes to all kinds of illustrations. One type of drawing that beautifully enhances almost any quote is botanicals. Flowers, plants and leaves are pretty, natural illustrations that can fill the empty spaces in a design. There are just as many ways to draw a flower as there are kinds of flowers in nature, but today we're going to focus on a few in particular. They can stand alone, or you can draw them in groups and color them in to add instant beauty to your lettered quotes.

"CAN I UNSUBSCRIBE FROM ADULTHOOD?"

Apparently, being a famous author and blogger means you get the privilege of being added to everybody's mailing list whether you like it or not. Thank goodness for that "unsubscribe" button, so I can try to put a stop to the hundreds of spam emails I get on a daily basis. Wouldn't it be awesome if there were a real-life unsubscribe button that got you out of other things you didn't want to do? Like adulting, for example. Remember when you were a kid and couldn't wait to grow up? It was so fun to imagine having a house and getting to do whatever you wanted instead of what your parents said. Then you became an actual adult. Now, if your life is anything like mine, it means you pay bills, work, cook and have to make hard decisions. You have to act responsible and exercise and maybe try to train a few children to be fantastic humans. I miss the days when my only job was to play, don't you? If you could please point me to the unsubscribe button, I'd be most appreciative.

FANCY FLORALS

Bring on the flowers: it's time to get fancy! We're going to look at several types of flowers and buds that will enhance your artwork. Each illustration is composed of basic shapes that anyone can draw, so don't be intimidated. Just follow the simple steps and you'll be creating floral masterpieces in no time. Let's get started.

MESSY CIRCLE FLOWER

If you've read my first book, *Hand Lettering for Relaxation*, you're already familiar with this, my favorite flower doodle. It's always the first type I teach because this flower literally couldn't be easier, and yet it looks incredibly pretty when it's drawn and colored in. The only thing you need to know how to do is draw a very messy circle and make a series of dots.

Start by drawing a circle and tracing over it several times without picking up your pen. Then, draw a group of dots in the center of the circle. That's it! Add a few leaves and you have a masterpiece.

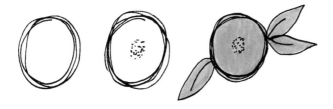

Now, we're going to take it a step further by creating a bud, as well as several other flower styles to mix with this old favorite and create beautiful arrangements!

FLOWER BUD

To create a bud for these flowers, sketch an oval that's slightly narrower at the top than at the bottom. Draw a curving line through the oval, staying to the left. You can add another curving line on the other side if you like to indicate petals that are present, but not opened yet.

SIMPLE ROSE

A rosebud may be the simplest of all flowers to draw, because all you need is a tiny spiral. To draw a rose in full bloom, start with that same spiral, then begin sketching curving petals around it. The next layer of petals should alternate with the first as if you were laying bricks, rather than lining up directly on top of the petals in the previous layer.

FIVE-PETALED FLOWER

Start this flower by drawing a circle for the center. Then, draw five large petals coming from that circle. You can shape them however you like—pointed, rounded or almost square—and you'll create distinctly different flowers.

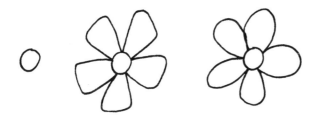

Once the petal shapes are drawn, sometimes I like to go back and draw a smaller shape inside each one. This allows me to make each petal two colors instead of just one, making my design even more colorful and fun. To finish, I add tiny dots on one side of the center circle and sometimes I even add a pattern to parts of the petals.

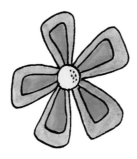

There's no wrong way to make these flowers, so have fun playing around with the different techniques and trying a few variations of your own. Then, when you're ready, go ahead and letter this chapter's quote on the border page, accenting it with your favorite florals.

As we learned in the last chapter, you'll want to start by breaking the quote down into lines, emphasizing the most important words with your font choices. I decided to split it into four lines, with "Can I" and "from" in Minimalist Print (page 14) and the other two words in Faux Calligraphy (page 10). Use your pencil and ruler to sketch four horizontal guidelines, one for each line of the quote, and then pencil in the positions of your words, starting with the center letters and working your way out to the edges. Then, it's time to add some of our flowers! You'll want to sketch the positions of your flowers in pencil as well, to make sure you like your composition. Don't worry about all the details; general shapes will give you an idea of how your piece will look. I made a little grouping of five flowers and two buds below the quote and added leaves. Then, I drew two curving lines, one on each side of the flowers, and added leaves. At the top, I drew two buds along with stems and leaves. You can do the same, or you can place flowers wherever you want them to be. When you're happy with your draft, go over everything in marker, including coloring in your flowers, and then erase any pencil lines you can still see once the marker is dry.

PRACTICE BELOW

STRENGTH FOR MY WI-FI

A No-Paint Watercolor Technique

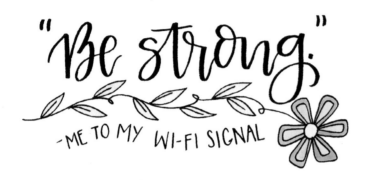

Color is one of the key elements of any piece of art. We can certainly use colored pens and markers when we do our lettering itself, but another way to make a design pop is by coloring in any embellishments and illustrations we've added. In this workshop, we'll be focusing on a simple technique that allows us to get the look of traditional watercolors without using any paint! It's great for filling in doodles as well as creating a colorful background. You won't believe how easy this is to do and how much it looks like real watercolor art!

"'BE STRONG.'
—ME TO MY WI-FI SIGNAL"

A few years ago, my brother-in-law got married. He had a destination wedding, but instead of being in a destination I'd choose, like Hawaii or Europe, he and his bride chose a tiny town in upstate New York. It was surrounded by the Catskill Mountains and not much else. The closest Walmart was more than an hour away, and as we followed our GPS along a winding dirt road, we suddenly lost all signal. There was no data and absolutely no Wi-Fi. I panicked. I was . . . disconnected! *Noooooooo!* How was I supposed to function for a whole weekend without my Wi-Fi?! If you've ever had to "disconnect," you may understand my terror. But despite my fears, I have to confess that we did have fun learning to play gin rummy with Great Grandma, who beat the pants off all of us, as well as relaxing and spending time with family. We also had a surprise visit from a bat that flew into our rental house, which was an interesting diversion. Watching my father-in-law try to chase it back outdoors while telling my mother-in-law it was a bird provided more amusement than you might expect. I don't know about you, but, as fun as these adventures were, if given the choice, I'd still take my Wi-Fi over an intruder bat any day.

A NO-PAINT WATERCOLOR TECHNIQUE

So how in the world is it possible to watercolor without paint? Trust me, you can do it, and it's easier than you think. All you need are water-based markers (I recommend Tombow Dual Brush Pens), a water pen (my favorites are the Pentel Aquash Pens or the FolkArt Water Brushes) and a nonabsorbent surface. You can use anything from a plastic sandwich bag to a laminated piece of cardstock or a plastic artist's palette. In a pinch, I've been known to use a trash bag or even the lid from a plastic container of potato salad! Just make sure that when you color on the surface, the ink pools and sits on top instead of absorbing like it would on paper. Once you've gathered your supplies, here's what you'll do.

STEP 1

Draw a simple shape or doodle with a permanent or non-water-based marker.

It's important to use the right type of marker for this step, because if you use something water based, the outline will smudge and bleed when you try adding the color inside in step 3.

STEP 2

Scribble with your colored marker(s) on the non-absorbent surface.

Don't worry about being neat or trying to create a pattern, the goal is just to get ink onto the surface.

STEP 3

Make sure the barrel of your water pen is filled with clean water, then dip the brush tip into the ink.

As you do this, the tip of the brush should start to take on the color of the ink. Use the water pen like a paintbrush to fill in the blank areas of your design.

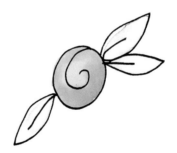

It's that simple! The water pen is self-cleaning, so as you transfer color to the paper, the brush will turn clear again. You can then reload it with more of the same color, or you can pick up a new color instead. If you want to change colors before you've run out of the first one, just move the water pen back and forth on a paper towel or a piece of scrap paper until the color is gone.

One of the best things about this technique is how easy it is to blend colors; just dip the pen into several different colors instead of one and they'll naturally mix together as you paint.

Here's an example where I created an ombré effect by starting with one color, then switching to a different color halfway through.

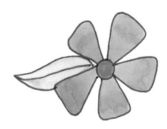

For this image, I colored in the petals and leaves, then went back over certain spots with other colors to create contrast and shadows.

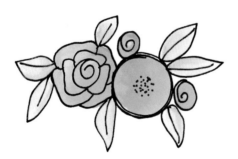

In addition to using this technique to color in illustrations, you can use it for doing your lettering itself. Just load your brush with color, then use it as you would your markers.

Use the practice space provided here in the book to try out this technique. If you want to practice further and create other projects, I recommend using hot press watercolor paper, because it's smooth and is specially designed to handle water.

In this chapter's quote design, we'll be coloring in one of the pretty petaled flowers we learned to draw in chapter 5. To start illustrating the quote, you'll want to pencil in a straight horizontal line, then a wavy line underneath. On the top line, you'll pencil in "Be strong" using Faux Calligraphy (page 10) and Bounce Lettering (page 17). Then, print the rest of the quote along the wavy line in Minimalist Print (page 14). In the bottom right corner, sketch your petaled flower, then bring a looping line out to the left for a stem with a few leaves. Trace your design with markers and use this brand-new watercolor technique to color in all the open spaces of the flower and leaves.

PRACTICE BELOW

SOCIAL VEGETARIANS

Advanced Composition

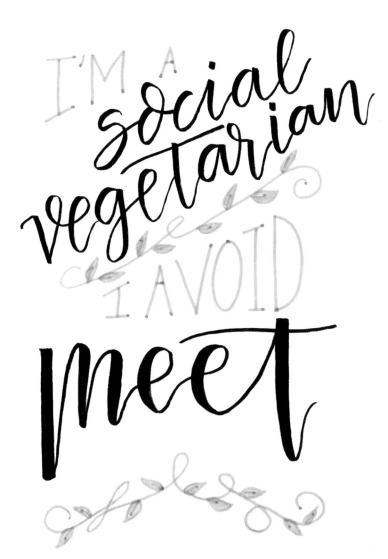

Now that you've mastered the basics of composition, it's time to take your skills a step further and look at a few more advanced ways to put together a design. One of the best ways to create a hand lettered piece that's visually balanced and interesting is to start by using a sketched design grid. You can make your own grids, or you can purchase them from lettering artists who create and then sell them online. A lettering grid provides basic spacing, shaping and positioning, then you can pencil in your quote by placing the words inside the sketched shapes. You can create tons of unique projects using the same grid, just by changing the words, fonts, colors and embellishments you choose. Let's take a look at how to create and use these grids in your lettering.

"I'M A SOCIAL VEGETARIAN. I AVOID MEET."

Let me begin by saying that I really do like other people. But I like them best when they text me, send me an email or want to spend time with me one-on-one. As much as I enjoy teaching and speaking in front of large groups, I can't stand being in large social gatherings. The older I get, the more I've learned to embrace my inner introvert and accept that I'm awful at making small talk. The bigger the group I'm in, the more time I need alone afterward to recharge. Can you relate? Does the thought of chatting with strangers make you want to crawl under the covers? Or are you like my extroverted husband and son, who thrive in social settings and love to be the life of the party? Just so you know, if you and I are ever in a crowded room together, I promise I truly am glad to meet you . . . from the other side of the room.

ADVANCED COMPOSITION: GRIDS

In our previous lesson about composition (page 21), we looked at how to break a quote into pieces and emphasize the most important ones. That's a great place to start, but as you gain more experience and look at examples of lettered art on Pinterest and Instagram, you'll probably find yourself wanting more. When it comes to more advanced composition, the best advice I can give you is to think about your design as a puzzle. Imagine the edges of your paper as a frame and it's your job to arrange a variety of shapes inside. Let me show you what I mean. Here is a look at the structure behind one of my lettered quotes, which is called a design grid.

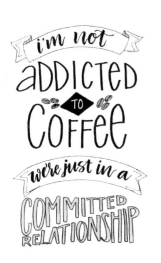

You can see that there are several kinds of shapes arranged together to fill the space. When I begin a design, I start by choosing or sketching my grid. I look at the quote I want to letter and decide what would be the best complement to those words. There are endless possibilities for what shapes you can use and how you can arrange them. Here are a few of the most common shapes I use.

There's no wrong way to put the shapes together, as long as they fit within the area where you'll be creating your design. However, some combinations are more visually appealing than others, so don't be afraid to play around with your design until you get something you love. Here are a few examples of ways to lay out a quote.

At first, these might just look like random shapes, but the grid starts coming to life when you add words and embellishments inside!

The length of your quote as well as the number and position of words you want to emphasize will help you determine which layout works best. Spend some time looking at other artists' work and see if you can figure out what the underlying grids are. Look at the way the words are shaped and positioned and try to sketch it on paper. Then, you can save that grid as a resource to try with some of your own lettering.

Pro Tip: If you're intimidated by the idea of creating your own grids, I highly recommend checking out the grid bundles by professional lettering artist Stefan Kunz at typoxphoto.com/shop. There are two bundles, each with 25 grids, for a very reasonable price. You can print them out as hard copies, use them on the iPad Pro, use them in Photoshop and more. They are a great starting point and will give you a feel for how composition works.

For our special design, we'll be using a grid that looks like this.

STEP 1

Sketch or trace a grid, then pencil in the positioning of your words.

Don't worry about technique or details; we're just blocking where each word goes.

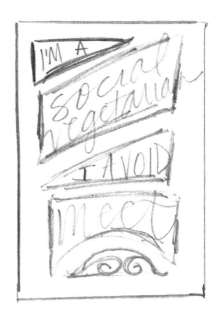

STEP 2

When you're happy with the quote placement, it's time to go back over the design with your markers and pens, using the fonts you've chosen and any embellishments you like.

Remember, some spaces on your grid can be for illustrations or flourishes, like the ones we learned in chapter 5, rather than words.

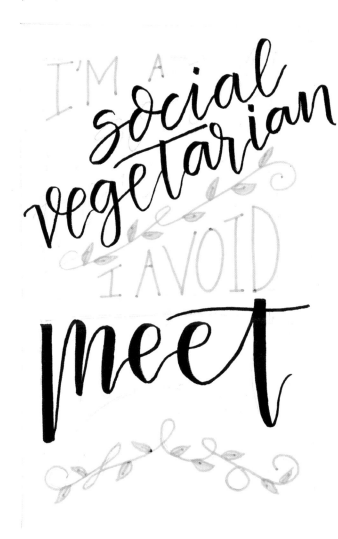

STEP 3

Erase any pencil marks you can still see, and your design is complete.

Now it's your turn! Take some time to sketch or copy a few composition grids in the space provided, then move to the border page where you'll start by sketching the grid shown previously. Then, pencil in your words and trace over them with marker. I used Minimalist Print (page 14) for the words "I'm a" and "I avoid," allowing my letters to increase and decrease in size based on their positions within the triangles. I used Faux Calligraphy (page 10) for the other words, once again shaping the letters to fit within the grid. Finally, I added two leafy vines for embellishments. The top is simply a little looping flourish, while the bottom one is based on the more complex multi-loop flourish we will learn in the next chapter. Feel free to recreate my design exactly, or to use any other embellishments or styles that appeal to you and make the design truly your own.

PRACTICE BELOW

MAKING RESERVATIONS

Fabulous Flourishes

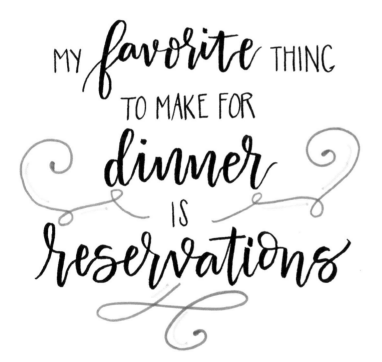

Many people seem to consider flourishes as both the most beautiful and most intimidating way to embellish a hand lettered design. I've talked to lots of folks who feel unsure about how to form flourishes and where to put them to achieve the gorgeous effects they've seen other artists create. In this book, we're going to take away the fear of flourishing and you'll be using these embellishments like a pro in no time. First, in this workshop we're going to look at some stand-alone flourishes, then in later chapters we'll tackle the special ones that can be attached to some of the letters in the alphabet. As we get started, remember, a flourish is nothing more than a curving line, and anyone can draw a line! Also, the faster you move your hand, the less shaky those lines will be. Ready to tackle this? Let's go!

"MY FAVORITE THING TO MAKE FOR DINNER IS RESERVATIONS."

I hate cooking. I know people who find great joy in whipping up delicious meals from scratch for themselves and their families. Maybe you are one of them. I am not that person. Please don't love me any less when I tell you that the vast majority of things I can cook come out of some sort of box. Partially, I'm lazy. Partially, I'm just not interested in it. I can think of a million things I'd rather do with my time than make a meal; for example, eat one. I'm a really awesome eater. So please, if we ever meet face to face and you want to chat over dinner, don't make me cook it. We'll both be a lot happier if you take me out somewhere. In fact, let's just scrap the meal altogether and meet for coffee. I'll see you at Starbucks.

FABULOUS FLOURISHES

When you look at the anatomy of a flourish, it's almost always composed of two basic parts: swirls and loops. What creates the distinctive look is how those two things are combined. Swirls are simply spirals, and they typically curl either upward or downward. Loops are areas where your line crosses over itself, like in a lowercase script "l" or "e." These generally point either upward or downward as well. That means we have tons of potential ways to link them together. If you're a logical, math-brained person, these "flourish formulas" will make perfect sense to you. If you're not (like me), bear with me . . . you'll see what I mean. Here are just a few of the ways you could combine the elements (shown with the Tombow Fudenosuke pen):

Downward Loop + *Upward Loop +*
Downward Swirl *Upward Swirl*

Upward Swirl + *Upward Swirl +*
Upward Loop + *Upward Loop +*
Downward Swirl *Upward Swirl*

Downward Swirl + *Upward Swirl +* *Upward Swirl +*
Downward Loop + *Downward Loop +* *Downward Loop +*
Downward Swirl *Downward Swirl* *Upward Swirl*

And on and on . . . the possibilities are endless!

In addition to linking the loops and swirls, you can also put them inside each other by drawing a loop inside a swirl. Simply start drawing a swirl in either direction, then at the end of it, instead of picking up your pen, form a loop! Don't be afraid to let your line cross over itself as you finish.

Try it out in different directions so you can place it anywhere in your design. I like to create my flourishes with a brush pen, but you can draw these with any markers or pens you have on hand.

Another way to create an interesting flourish is by using more than one loop. I like to do this by starting with a downward loop, then going right into an upward one. Finish off your flourish by moving your pen around in a little swirl either to the right or the left.

Add extra pizzazz by drawing two lines between the loops and some short lines around the outsides. Or, you can experiment with allowing your ending swirl to be very large, crossing over the center part of your flourish.

Remember how we just learned to make a swirl with a loop inside? Try using that technique for your first loop!

Here's one final multi-loop flourish that takes some practice, but I think you're going to love it. Here is the formula:

Downward Spiral + Upward Loop + Downward Loop + Upward Loop + Upward Loop + Downward Loop + Downward Spiral

I have to be honest, I went through a few sheets of practice paper when I was first learning this one before I got it to look the way it does now. Don't stress out if it doesn't look perfect the first time you try! Feel free to trace over mine a few times to get a feel for how your pen needs to move, then try it on your own.

These examples are just a small sampling of the many types of flourishes you can create to accent your artwork. Rather than using them as a list of exactly what to do, I hope you'll look at them as a springboard for how to create all kinds of possibilities. Use the space provided to experiment with loops and swirls, creating a variety of flourishes. Don't forget, the slower your hand moves, the more likely you are to get shaky lines. Even if you're not 100 percent sure what you're doing, move quickly and with confidence. Feel free to sketch with pencil first if it makes you more comfortable, then trace your lines with marker once you know you like how they turned out.

Once you've gotten the hang of some of these flourishes, you'll love seeing how they enhance your artwork! Stand-alone flourishes look great at the top or bottom of a design, and they also do a great job of filling in any empty spaces. You'll want to make sure to keep things symmetrical; for example, it looks best to have a flourish on both sides of a word rather than just one side.

You'll also want to take your flourishes in opposite directions rather than making them the same on both sides of your design to create visual balance.

To choose which flourish works best in a particular design, I look at the size and shape of the blank space I have and try to think of what would best fill it.

Now, let's put some of our new flourishes to work in this chapter's quote design. In the last chapter, we talked about the concept of design grids; here's what that looks like for this particular illustration.

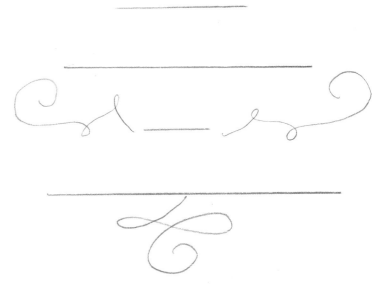

First, we'll need to sketch five horizontal lines, then pencil in our words in a mixture of Minimalist Print (page 14) and Faux Calligraphy (page 10). Remember to try out your Bounce Lettering (page 17) for the words in Faux Calligraphy and let the letters move around a bit within your words. Once your words are in place, it's time to add whichever flourishes are your favorites. You can use the same ones I chose for my sample design, or you can use a combination of others instead. You'll want to pencil them in first to see how the lines and shapes work with the words; then, when you have something you like, go ahead and trace over everything with markers.

PRACTICE BELOW

WHAT'S INAPPROPRIATE?

Highlighted Letters Font

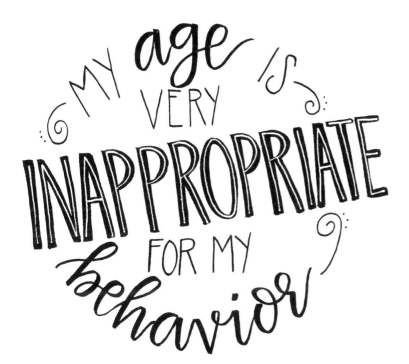

Within a quote, there will always be certain words you want to emphasize. One way to do this is by using a large, dark font that will capture your viewer's attention. The Highlighted Letters Font is a great choice because it's both bold and interesting, and it seems to pop right off the page. To create it, you'll need a black marker with a large bullet tip, as well as a white gel pen, so let's find those essential supplies and take a look at how this font is formed.

"MY AGE IS VERY INAPPROPRIATE FOR MY BEHAVIOR."

It's inevitable that all of our bodies will grow and change as we age, but there's no rule saying how we have to act. Just because we've got more years of life experience under our belts than we once did doesn't mean we're forced to become serious and cranky. If you've ever heard someone say, "You're only as old as you feel," you know just what I'm talking about. Each of us only gets one life to live, so we might as well enjoy it at every age, am I right? So, play that prank, dance to the music you hear and don't be afraid to let your hair down sometimes. Be silly. Ride a roller coaster. Play with little kids. Eat a hot fudge sundae instead of a banana every once in a while. You have my permission.

HIGHLIGHTED LETTERS FONT

Before we can get to the highlights, which are the best feature of this font, we have to create our base, which is dark, thick, simple letters. These letters are sans serif, meaning there are no little lines on the ends, and they are free from other embellishments because we want the highlighting to be their primary feature. To draw the letters, we're going to use a large marker and focus on creating neat, precise forms. If your marker doesn't make the lines as thick as you'd like them to be, you can draw a second line to make them larger. The letters need to be about twice as thick as the line made by your white gel pen. Here's the alphabet for this first step.

ABCDEFGHIJKL
MNOPQRSTUV
WXYZ

Now, we're going to go back and add the highlight lines to our letters by using the white gel pen right through the center of our black lines.

Here's the entire alphabet with the highlights included.

ABCDEFGHIJKL
MNOPQRSTUV
WXYZ

As you can see, this font is very simple to create but has a powerful impact. I like to use it to emphasize important words in a quote because it's bold and dark.

Pro Tip: This technique doesn't have to be limited to the font we just created; you can also use it to highlight other types of letters, designs, flourishes and shapes! You can also mix things up a bit by using dots instead of or in addition to your lines.

Here, we're going to use it for the word "inappropriate."
Take some time to practice writing that, along with any
other words you'd like to try, in the practice space provided.
Then, let's combine it with some of our other skills to create
a finished design.

Here is the grid composition for this quote.

We're going to start off the quote by lightly sketching a
circle in pencil. I recommend tracing a coffee mug or small
bowl that's the size you want your design to be. Next,
sketch two parallel diagonal lines through the center of
the circle. These will be the guidelines in between which
you'll write the word "inappropriate" in our new font.
Next, you'll pencil in the words "My age is" around the top
of the circle in a combination of Minimalist Print (page 14)
and Faux Calligraphy (page 10). Around the bottom of the
circle, write "behavior" in Faux Calligraphy. All that's left
is to print the remaining words and add a few little spiral
embellishments to fill in the rest of the empty space.

Once you're happy with the look of your quote, trace
over it in marker and erase the pencil marks to finish your
masterpiece.

RETAIL THERAPY

Variations on a Banner

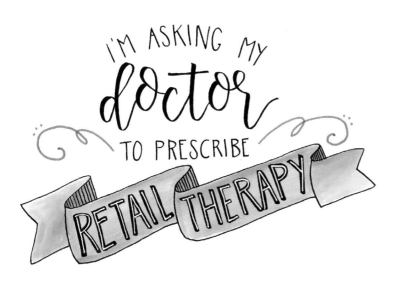

One of my favorite ways to embellish my lettering is by drawing festive banners, then writing inside. Not only are banners a great way to emphasize certain words in a quote, but they're also perfect for handmade cards and gifts to celebrate an important occasion. Once you've mastered a basic banner, there are a number of fun variations you can try. In this workshop, we're going to look at several of those variations, take some time to practice them and then use your favorites in the featured quote design.

"I'M ASKING MY DOCTOR TO PRESCRIBE RETAIL THERAPY."

What is it about shopping that feels so darn good? Maybe it's the thrill of having something new. Perhaps it's the idea of treating ourselves or finding the perfect gift for someone else. It could be the satisfaction of finding a great bargain. Whatever it is, I think there should be a way to consider it as an effective form of therapy. I mean, can't I get my doctor to write me a prescription for it? Then I can show it to hubby and prove how good and necessary it is. I mean, who am I to defy doctor's orders?

VARIATIONS ON A BANNER

Let's take a look at four different types of banners you can use to accent your hand lettering. Each one is created by sketching basic lines and shapes; they're easier than you think.

PARTIAL BANNER

This little piece of a banner is perfect for monograms and small words. It pops on the page and adds just enough flair. If you keep a written calendar or journal, it can be a great place to put the date or a phrase like "to do." Simply draw three sides of a rectangle, then make the final side into an inverted "v."

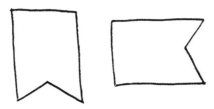

You can add variety to this type of banner by coloring it, adding details like little stitches around the edges or making both sides into "v" shapes.

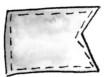 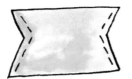

PENNANT BANNER

Typically, when I think of a banner, I think of one long piece that contains my word or phrase inside. However, we can also create a festive look with a totally different type of banner, one that's made up of a series of little pennants instead. To draw this, you'll start by making a curving line. Then, beginning in the center, draw a "v" shape to create the pennant. Continue drawing "v" shapes along the line until it's filled.

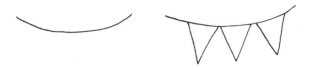

You can simply use this as a cheerful border for your designs, or you can incorporate it into your lettering by placing one letter of a word inside each pennant.

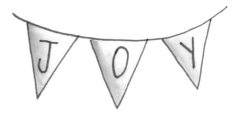

Another variation on this type of banner is to change the pennant shape to the partial banners you just learned.

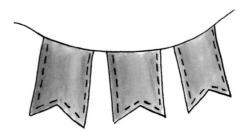

WAVING BANNER

This is the most popular banner style, and it's a great way to brighten up any lettered design. Start by drawing a curved line, as shown below, then draw another one below and parallel to it.

Draw two vertical lines to connect the top and bottom of the banner. Then, add inverted "v" shapes on each end to finish off the shape.

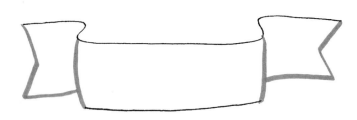

The last step is to add short vertical lines to create a shadow effect where the ribbon loops over itself.

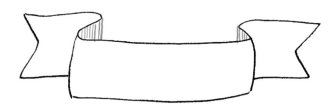

You can color in your banner using the No-Paint Watercolor Technique (page 30), then letter inside. It's always a good idea to pencil in your words first to make sure you have enough space!

FOLDED BANNER

The banner style I use most frequently is a variation on the waving banner, but rather than having both ends come from behind, I draw it so that one end folds behind while the other goes in front. To start this doodle, you'll draw a curving line again, but with a different shape.

Draw two vertical lines, one coming from each of the fold spots.

Draw horizontal lines to create the bottom of each section of the banner. Then finish each tail with an inverted "v."

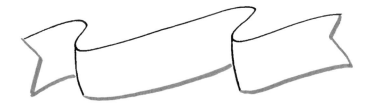

Finally, add the same type of details you did for the waving banner to finish it off.

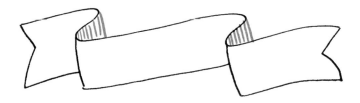

To make this banner longer, you'll just add more folds, like we'll do in today's quote design. Take some time to practice the different kinds of banners in the space on the right. Which ones are your favorites? Then, we're going to letter this quote all about shopping!

For this design, our composition grid will look like this: an arch, two horizontal lines/rectangles and a double banner on the diagonal. Sketch these shapes lightly with your pencil, then start filling in the words.

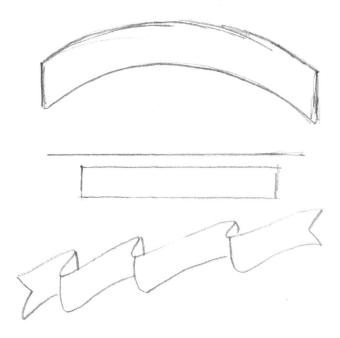

I used Faux Calligraphy (page 10) for "doctor," Highlighted Letters Font (page 45) for "retail therapy," and Minimalist Print (page 14) for the rest. Then, I added two looping flourishes (page 39), one on each side of the design for balance. Once your design is penciled in, trace everything with marker. You'll want to color in your banner with the No-Paint Watercolor Technique (page 30) before finalizing the lettering on top. Use your own favorite colors to personalize your art.

THIS HOUSE IS DIRTY

Accenting the Small Words

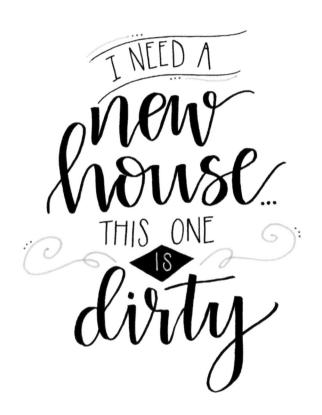

Almost every quote you can think of contains at least one "small word." What does that mean? I'm glad you asked. I was an English teacher for four years in what feels like a former life, so I'm going to geek out on you for a second; bear with me and take a quick trip back to the classroom. What we're calling "small words" are the ones the English language requires us to use so we make sense, but they're not the ones that pack a powerful punch when it comes to meaning. We're talking about things like conjunctions, pronouns and

definite articles. Here are some examples: "and," "or," "but," "the," "an," "it," "she." Sometimes, forms of the verb "to be" fall into this category too, like "is," "were" and "are." When we're laying out our designs using the composition skills we've been practicing, one of the easiest things to do with words like this is make them smaller and de-emphasize them by our choice of font and placement. However, sometimes it can be fun artistically to add a little pizzazz to them instead, accenting them in ways that are visually interesting without taking away from the most important parts of the quote. Let's take a look at a few simple ways to accent those small words in your favorite quotes.

"I NEED A NEW HOUSE...THIS ONE IS DIRTY."

The last time I cleaned the house really thoroughly, it looked amazing. And it took my boys about 0.8 seconds to destroy it. There were toys everywhere because the kids decided to set up a pretend restaurant and got out every piece of fake food they own, then they had a lightsaber battle in the middle of it. The cat kicked litter all over the floor and dragged it through the house. There was dirty laundry and a sink full of dishes, and I thought to myself, "Why do I even bother?" Seriously. I can't be the only one who feels this way, right? Can you feel me on this one? I live with two little boys and a grown-up one. I am fighting a losing battle. And so, I quit. I won't let us live in filth, but if you come to my house, you should fully expect to see toys and maybe a few random socks on the floor. Expect to see piles of papers I'm not sure what to do with and half-finished art projects. I hope you're okay with that, because we live here, at least until we can afford to move to the beach.

ACCENTING THE SMALL WORDS

I wish you and I could spend the afternoon doodling together over a cup of coffee so that I could show you all my favorite accents for the little words in a design. We'd talk and giggle and I'd say, "Oh, try this! Here's another one!" until you had a whole notebook full of ideas. Unfortunately, there simply isn't enough time to devote to this topic to give you every trick I have. So, for now, we'll have to settle for four to get you started.

GEOMETRIC SHAPES

One eye-catching way to accent a small word is by placing it inside of a geometric shape. Not only does it add visual interest, but also the shape itself can help provide balance and fill white space in your design. Personally, I like to use diamonds and circles, but you could use any shape that works best in your quote. Simply draw the shape, then write your word inside.

There are several ways to really make this technique pop. One is to make the shape a bright color before adding your word. Another is to use a dark color, then write your word on top with a white gel pen.

ON THE DIAGONAL

Just as we can play with the alignment and shaping of important words in our design, we can change those things for our smallest words. Try drawing a set of parallel diagonal lines and writing your word inside. Then, experiment with adding swirls or other little embellishments like dots and short lines.

FLOURISHED

Border your small words using a series of flourishes for an elegant design. Create your design above the word first, then mirror the flourishes below it.

BANNERS

Another shape we can use to frame our small words and phrases is that of a simple banner. As with the geometric shapes, you'll want to sketch the banner, then color it in and letter your word(s) on top. Be sure to sketch the positioning of the words in pencil first so you don't end up running out of space before you finish your lettering.

These are just a few of the many ways you can embellish and accent the less significant words in your art without calling too much attention to them. Instead, you'll be adding balance and interest to your overall piece. Which method is your favorite? In this chapter, we're going to practice this skill as we letter our featured quote design. Feel free to experiment with your own ideas, too, and to use whichever techniques you like best.

To create the featured quote design, we're going to start by sketching a set of waving lines on a slight diagonal. These will be the frame for the "little" words that start our phrase. Next, we'll pencil in three horizontal guidelines, followed by a small diamond shape and one final horizontal line. Here's how the grid looks.

PRACTICE BELOW

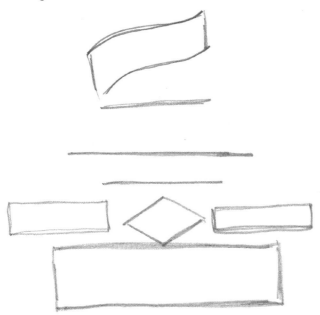

Then it's time to sketch the positioning of our words. "New," "house" and "dirty" are done in Faux Calligraphy (page 10) in my sample design, while the other words are all in Minimalist Print (page 14). Trace over your words with markers, then add a few embellishments on either side of the diamond. I also added some extra lines and dots at the top of the design. As always, feel free to play around with fonts, colors and layout if you'd like to give the quote your own flavor.

BECAUSE, COFFEE

Creating Coffee Doodles

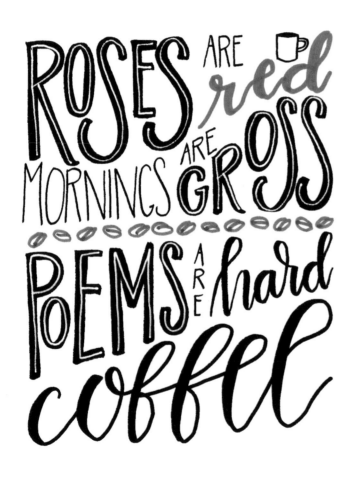

I don't know about you, but I think my birthstone should have been a coffee bean. I depend on coffee to help get me through the day, and I'm pretty sure I'm not alone. Naturally, every time I see a quote about my favorite beverage, it speaks to my soul and I want to letter it for myself . . . which means I've also spent some time learning to embellish those quotes with fun little doodles, like coffee mugs, to-go cups and coffee beans. In this chapter, I want to share those with you so you can use them to embellish your own favorite caffeinated quotes.

"ROSES ARE RED, MORNINGS ARE GROSS, POEMS ARE HARD, COFFEE."

As I write these words, I'm sipping on some coffee. Why? Partially, it's for my own benefit because it helps me wake up and be a productive member of society. Partially, it's for others. I happen to know I'm no picnic to be around in the morning. Coffee keeps me from hitting things and saying things I'll regret later. You may be nodding in agreement as you sip on your own cup o' joe. If so, cheers, friend. You and I already have a lot in common. However, if you're not a coffee lover, that's okay too. Maybe tea is your cup of, well, tea. Perhaps you thrive on energy drinks or soda instead. Whatever your go-to is, raise it in the air and let's have a toast. Here's to us doing whatever we need to so we can get through the morning. Let's get going and kick today in the tail. We've got this, friend.

CREATING COFFEE DOODLES

Every cup of coffee is as unique as the person drinking it, but if we learn to draw a few basic shapes, you can customize them as much as you like in your own work. Let's start with a basic coffee mug.

COFFEE MUG

Draw two vertical lines that are parallel to each other. Connect those lines at the top and bottom by drawing two curving lines shaped like smiles. Draw a line across the top of the mug that slightly arches like a rainbow. On the left side of the cup, draw two "c" shapes, one inside the other, to form a handle. If you'd rather have the handle on the right, just make a backward "c" instead.

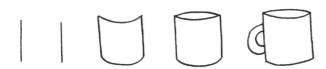

Now your coffee mug is ready to color! Feel free to add a pattern or words to make it more personal. You can change the size and shape of your mug by playing around with the length of your vertical lines and how much space you leave in between them. Taller lines make a taller mug, while shorter lines that are far apart make a mug that's short and squat.

TO-GO CUP

If we're being honest, I spend more time and money than I'd like to admit at the coffee shop, so when I think about a coffee cup, a to-go cup comes to mind before a mug. Just like any other illustration, a to-go cup is composed of lines and basic shapes, so it's actually really simple to sketch.

First, draw two vertical lines that are closer together at the bottom than the top. Connect the lines at the bottom with a line that curves upward like a smile. This is almost like the start of a mug, but your cup will have a tapered shape. Draw a long, thin rectangle on the top of the cup. It should extend out past the sides. Finish the cup lid by drawing another rectangle on top. This one should be the same width as the widest part of the cup.

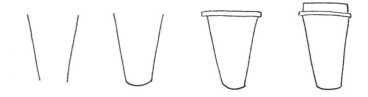

Add a cup sleeve by drawing two curving lines across the center section of the cup. Feel free to add details like a logo or pattern. When the drawing is complete, you can color it in with colored pencils, markers or the No-Paint Watercolor Technique (page 30).

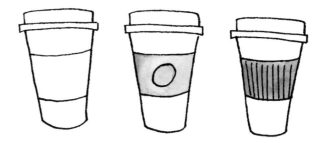

COFFEE BEAN

One final touch I love to add to a good coffee quote is a coffee bean! These are adorable little accents and can be used alone, in groups or even as a border.

Start by drawing a small oval. Then, draw a straight line through the center.

That's all it takes! An oval and a line, and you've got yourself a cute little bean. Just color it brown and there will be no doubt what it is.

Don't worry about making all the lines perfectly straight or in exactly the same place. No two coffee beans are alike, so allowing some variation makes them look more realistic.

Take some time to practice these doodles in the space below. Then, let's get ready to tackle our quote!

Here's the grid we'll be using for this chapter's featured design. The top section is like a rectangle divided with a waving line. Then there's a long, thin rectangle where we'll be using some of our coffee beans. At the bottom is another large rectangle split into two pieces with a diagonal line.

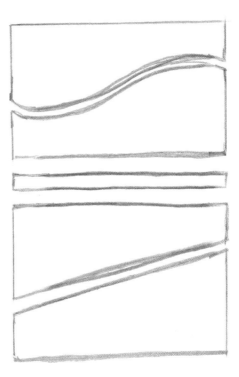

To letter our design, we'll be combining three fonts: Highlighted Letters (page 45), Minimalist Print (page 14) and Faux Calligraphy (page 10). We'll also be bringing in some of our coffee doodles, specifically the beans and your favorite style of cup. Sketch the grid onto the border page and fit your words inside with pencil first, then trace over everything with marker to finalize it when you like how it looks. Of course, you can also create your design in any other arrangement or style you prefer. Have fun with it and enjoy the process!

PRACTICE BELOW

NOT A MORNING PERSON

Double Trace Font

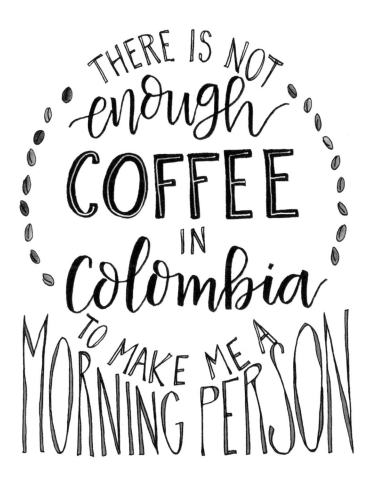

Sometimes, a simple monoline print font looks just right in a design, but there are also times when you might want your letters to pop just a little more. Today, we're going to look at a print font with that extra little something to make it stand out. The best part about this font is that it's not perfectly precise; it's meant to look hand drawn, so you can breathe easy and just enjoy creating it. All you'll need is a fine-tip marker and you're ready to letter what I call the Double Trace Font.

"THERE IS NOT ENOUGH COFFEE IN COLOMBIA TO MAKE ME A MORNING PERSON."

Do you like mornings? As for me, I am the farthest thing from a morning person that you can imagine. However, for some reason, God thought it would be hilarious to give me parents, a husband and two children who are the most cheerful morning people you ever did see. I'm the oddball, and boy do I hate getting out of bed. My husband learned early in our marriage to give me space and silence until I fully wake up. My kids have not yet learned this. Mornings are gross and rude and the only saving grace about them is that there's coffee. But no matter how much of it I drink, please don't ask me to do anything important before 10 a.m. We'll all be better off that way.

DOUBLE TRACE FONT

One of the hardest things for me about teaching fonts is coming up with what I want to call them. This particular font got its name because to create the letters, you literally write the letters, then go and trace over them again to create a second set of lines. Sounds simple, right? Here's how it works.

STEP 1

First, you'll write your word with a fine-tip marker.

When I use this font, I always write in all caps. I'm not exactly sure why—there's no reason you can't do it with the lowercase alphabet too—but I personally stick with capital letters. Don't worry about leaving any extra space between your letters. The tracing will follow the original lines very closely, so you don't really need more room.

ENOUGH

STEP 2

Go back and write each letter again on top of the letters you already wrote.

You don't want to trace the letters exactly; you want some places where the lines merge together but others where they are slightly apart from one another like in the example below.

ENOUGH

There's no exact rule for where the lines go, you just want it to look as though you've traced over the letters, sometimes ending up slightly outside the original . . . which is exactly what you did!

Here's what the whole uppercase alphabet looks like written in this style, but remember, it's just a general guide. Each time you write a letter in Double Trace Font, it will look slightly different based on where your lines happen to fall, and that's okay. In fact, that natural hand-drawn variation is exactly the look we want.

ABCDEFGHIJKL
MNOPQRSTUVW
XYZ0123456789

To take this font to the next level, there are several variations you can add. One of my favorites is to fill in any spaces with color. You could also add a pattern, like tiny dots, if the space is large enough.

If you tend to be a perfectionist, this may actually be one of the more difficult fonts for you, because you have to let go of control and let your letters get a little messy. If you're like me, it may be your favorite thing yet, because you don't need to be perfect and precise; you can just write first and think about it later. Either way, spend some time trying out some words and phrases in the practice space below. Then, let's put this font to work in our featured design on the border page! Here's the grid we'll be using to lay out our quote.

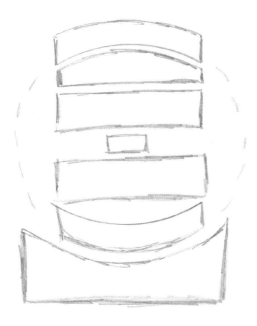

We'll be using our brand-new Double Trace Font for the words, "There is not," "to make me a," and "morning person." The other fonts we'll be mixing in are Faux Calligraphy (page 10) and Highlighted Letters (page 45). To add a little more visual interest, once the words "morning person" are lettered, we're going to color in the areas where there's space in between the double traced lines. Finally, we'll be embellishing by drawing and coloring in a little border of coffee beans, which we learned in chapter 12 (page 60). You can refer to my sample design for word styles and positioning, and you can also make whatever changes you like to make your creation unique.

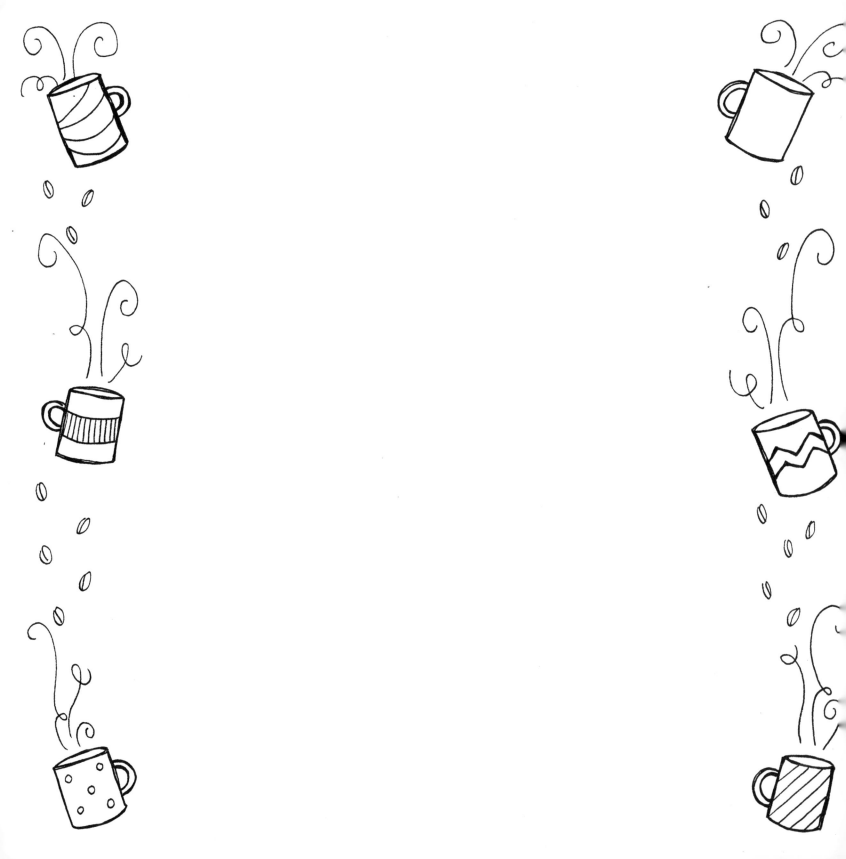

DR. SEUSS AND COFFEE

Flourishing the Ascenders

One of the easiest ways to take your lettering to the next level is by combining two things you already know how to do: flourishing (page 39) and Faux Calligraphy (page 10). By adding flourishes to your letters themselves, you can embellish a design, making it elegant or whimsical in no time. There are certain letters, particularly those with ascenders and descenders, that are perfect for this kind of embellishment. We're going to begin by looking at letters with ascender lines, such as "b" and "d," and practicing a few styles of flourishing with them. Let's get started!

"I WILL DRINK COFFEE HERE OR THERE. I WILL DRINK COFFEE ANYWHERE."

While we're on the subject of coffee, let me just say that there is a right place and time to drink coffee. Are you ready for it? *Right here and right now.* Am I right? Are you always up for a cup, too? It doesn't matter what I'm doing, if you say, "Let's go to Starbucks," I'll be in the car in a matter of seconds. I've had coffee on the beach, coffee in the woods and coffee on airplanes. If you've attended one of my workshops or a conference where I was speaking, you probably saw me drinking coffee while I presented. I've even had coffee in China! No matter where I am, if you bring me a coffee, I'll drink it. Speaking of which, my absolute favorite is a grande iced salted caramel mocha, nonfat, no whip, with extra caramel drizzle. You know, just in case.

ASCENDER FLOURISHES

In this workshop, we're going to look at several ways to add extra flair to ascender lines. As we learned in the Bounce Lettering chapter (page 17), an ascender is any line that extends above the main body of a letter. One way to flourish an ascender is by starting your letter with a longer than normal horizontal line to the left of where you want the letter to go, like in the examples below.

To embellish even more, begin that line with a loop before continuing over to make your letter. Your loop can go in either direction and be any size you like, but be careful not to make it look too much like an "e."

Now, instead of a loop, you're going to try adding a spiral to the beginning of your line. Experiment with a simple spiral first, then try a larger one that crosses over itself.

Finally, let's play around with the loops that are built into letters like "b," "d," "k" and "h." A pretty way to embellish these is by letting them be larger than usual and extending them to the right of your letter.

As you try these techniques, don't forget to keep your pen moving quickly so that your lines will look smooth. Just like when you're drawing stand-alone flourishes, if you're thinking hard and moving your pen slowly to get everything perfect, you'll end up with shaky lines. Fortunately, we're just practicing and learning right now, so if you make a mistake, no worries! Just try again.

There's no specific rule for when to use each kind of embellishment—that's part of the joy of lettering. It all depends on your artistic vision how much, when and where you use these flourishes. Usually, I look at the words themselves and where the letters are positioned to help me decide how I want to write them. In the practice space, try these ascender flourishes and see which ones are your favorites. Start out by practicing individual letters, then move on to simple words that start with ascender letters, like "bat," "ball" and "hat."

When the ascender letter occurs in the middle of a word or at the end, you can still flourish it in the same way. Rather than connecting your script letters the way you usually do, pick up your pen before writing the ascender letter and allow it to start to the left over the top of your other letters, above the x-height line we discussed in chapter 3 (page 17).

Isn't it amazing how something as simple as extending a line or adding a little swirl can give a word a totally different appearance? In the coming chapters, we'll be looking at how to add similar flourishes to other parts of your lettering. For today, though, let's put these skills to work in a fun and whimsical design, inspired by coffee and Dr. Seuss.

Here's a look at the basic design grid for our illustration.

To create this quote. you'll first want to sketch six horizontal lines on your paper, one for each line of text. Then, write the words "I will" in the center of the first and fourth lines in the Double Trace Font (page 63). Lines three and six are written in our Minimalist Print Font (page 14) using a thick marker. For the "or" in line three, you'll want to draw and color in a black circle. then write on top with a white gel pen. On lines two and five, you'll use Faux Calligraphy (page 10) to write "drink coffee," adding ascender flourishes to the "d" and "k." Feel free to use any combination of the styles we learned. Finally, you'll accent your design with two looping arrows and two "to-go" coffee cups. I colored mine red and white like the hat from Dr. Seuss's famous book *The Cat in the Hat* as an extra little tribute to the inspiration for the quote. Once your design is sketched, go over it with your markers and erase any remaining pencil lines once dry.

PRACTICE BELOW

RETURNING MONDAYS

Crossing Your "T"s

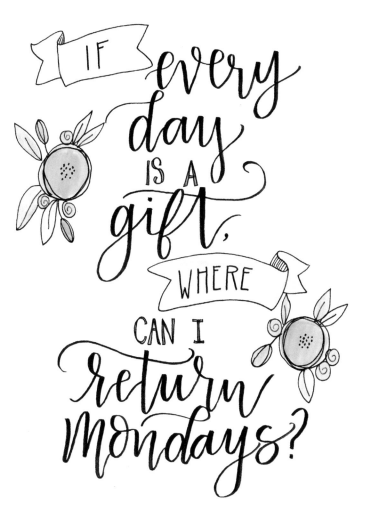

The letter "t" is probably my absolute favorite letter because you can easily accent it with a variety of different flourishes. The length and style of the crossbar is a stylistic choice you make each time you cross a "t." It's one of the easiest ways to flourish within a word, and as long as you follow a few very basic rules, you can't go wrong. Let's learn those simple guidelines and play around with all the different ways to make your "t" a work of art.

"IF EVERY DAY IS A GIFT, WHERE CAN I RETURN MONDAYS?"

I'm sure you've heard someone say that each day we have is a gift. It's true, you know—none of us is guaranteed tomorrow, so every day we have is one we should cherish and enjoy to the fullest. But, seriously, can't there be some kind of exchange policy for Mondays? It would be one thing if every day were just as good as the next, but we all know that's just not true. Weekends are way better than workdays, and even the weekdays themselves have a hierarchy. Fridays are best, then we have to weigh other things like how close each day is to the weekend and what food we get to eat (hello, Taco Tuesday!). I think we'd all agree, though, that Monday comes in dead last. Why can't we take our Mondays and exchange them for some extra weekend time? I'd even trade for extra tacos or some Wednesdays. Can someone look into this for me, please?

CROSSING YOUR "T"S

Let's talk for a minute about the anatomy of a "t." In its most basic form, it's a downstroke with a horizontal crossbar. Seems pretty simple, right? But within that crossbar, there are infinite possibilities! We're going to look at several of my favorites today, and I think you're going to love them as much as I do.

There's really just one rule to follow when it comes to stylizing a crossbar: Make sure the ends of your line curl in opposite directions, never the same way. Here's why. If both ends curl down, your "t" looks like it's frowning or like it ought to be an umbrella. If both ends curl up, you have a cactus. You may already know this rule, but it's important to mention because without it, your designs won't look quite right.

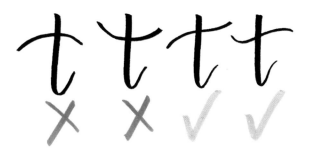

Instead, you want to get in the habit of making a wavy line where the ends balance each other out. If one end swirls up, the other should go down. If one side is high, the other side should be low. Try writing a few of these lines to get your pen moving. Now, let's look at how they work to form our "t."

SIMPLE SWOOSH

The easiest way to flourish a crossbar is by creating one of the wavy lines you just practiced. It can be equal in length on both sides, or longer on one side than the other.

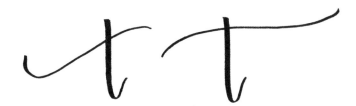

LOOPING SWOOSH

Add a small loop to your line either before or after it crosses over the body of the "t." Make sure you keep it tiny or very flat so that it's not mistaken for another letter like an "o" or an "e."

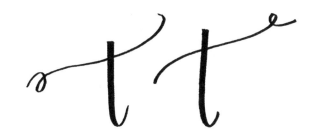

LIGATURES

A ligature is what you get when you combine two letters to make one new shape, like in the case of "th" if you use the crossbar of the "t" to become the loop of the "h," as shown below. This also works for other combinations, like "tt," "tl" and "tr."

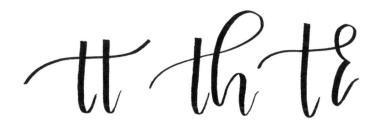

If you'd like to take it a step further, here are a few ways to add extra flourishing to these types of letter combinations. We'll just be using some of our basic flourish skills and putting them to work in a new place.

Usually, it's easy to choose which type of crossbar you want to use based on the words you're writing and what kind of space you have around the "t." In a word full of tall letters, it's harder to do a large, sweeping embellishment than it is in a word where "t" is the only ascender. The more you practice, the easier it will be to figure out which way you want to embellish your "t" in any given design.

Take some time in the practice space below to try these different techniques by themselves as well as in some words like "not," "teach," "tell," "gift" and "return." Then, turn to the border page and get ready to create our fun featured design!

Now that you have fifteen lessons under your belt, you've got a great variety of skills to combine as we letter our quote. We're going to be using three different fonts, along with banners (page 49), florals (page 26) and our No-Paint Watercolor Technique (page 30). We'll also be incorporating Bounce Lettering (page 17) and flourishes on both ascenders and "t"s. Are you ready? First, we need to sketch our design grid, which looks like this.

Then, it's time to position the words. Use my sample design to show you where each word is placed. Don't forget to have fun adding flourishes to your "t"s and "d"s! Trace your words and banners with marker, then erase the pencil lines. In the white space to the left and right of the design, sketch little arrangements of flowers, buds and leaves. You can imitate mine or come up with your own combination. When you're pleased with the look, trace over them with marker, then color in the flowers and banners with the No-Paint Watercolor Technique (page 30).

PRACTICE BELOW

IT'S TOO PEOPLE-Y

Flourishing the Descenders

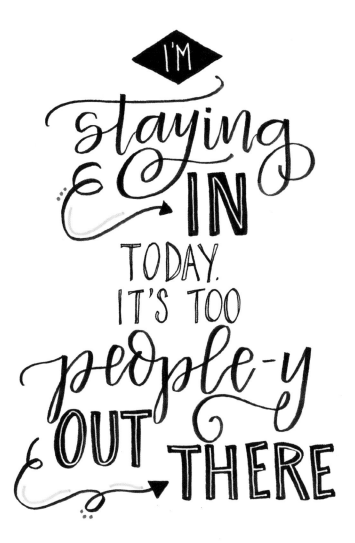

Just as some letters have ascender lines that lend themselves to flourishing, other letters have descenders that do the same thing. In this chapter, we'll be focusing on how to add elegance and flair to letters that extend below the baseline, like "p," "y," "j," "q" and "g." We'll look at several different options for embellishing those descender lines, then practice them in a quote that you're going to love if you happen to be an introvert like me!

"I'M STAYING IN TODAY, IT'S TOO PEOPLE-Y OUT THERE."

I have to admit, I'm addicted to my Apple Watch. Do you have one, too? With just a few swipes, you can check your email, reply to a text and check the weather anywhere. In fact, one of the first things I do every morning is check the forecast so I can tell my kids whether they need shorts, pants or sweatshirts for the day ahead. It's great having an app on our watches or phones that tells us just what temperature and what, if any, precipitation to expect when we step out of the house. But what I really wish is that there were an app I could check to tell me how many people I'm going to run into if I go somewhere. Will the grocery store be crowded? Will I run into lots of folks I know at Walmart? How many other parents will be at that school event? Wouldn't that be amazing? Then I could decide to stay in when it's just too people-y out there.

FLOURISHING DESCENDERS

There are more different ways to flourish a descender than we could possibly cover in one chapter, but we're going to start by learning five of the most popular ones. Once you've mastered those, you'll feel more confident trying some of your own ideas and imitating things you see artists doing on Pinterest and Instagram. You can use these descender flourishes wherever your letter appears, whether it's at the beginning, middle or end of a word or phrase.

SIMPLE SWIRL

The simple swirl is the absolute easiest flourish to do. Write your letter normally, then add a little swirl onto the end of your line that crosses back over the descender before you pick up your pen. That's all there is to it!

LOOPING TAIL

A looping tail flourish is just what it sounds like; write your letter. then add a little downward loop to the end of the tail before picking up your pen. Make sure the loop points down and stays very small so it's not mistaken for another letter.

LOOP-DE-LOO

To create this fun flourish, start making your letter as usual, then as you bring your pen back up, make a small downward loop before you cross over the descender line. You can see in the samples below that you can play around with how large to make the loop and how you position it.

BACKTRACK

Unlike the other descender flourishes, the backtrack finishes to the left of your letter. I particularly like to use this technique with letters at the end of a word, because then it underlines my other letters. Start out like the loop-de-loo, then instead of finishing your tail up and to the right, you'll go to the left and end with a little swirl.

CROSSOVER LOOP

The crossover loop is the most intricate of these flourishes, and it adds instant elegance to whatever you're writing. It starts like the loop-de-loo and the backtrack, but this time after making the loop, you're going to go a little to the left and then back to the right, crossing your line through the loop you just drew.

These are all great ways to start adding embellishment to your descender letters and taking your lettering to the next level. Over time, you'll find which ones you prefer, and you'll start to see which ones fit best into your designs. Take some time in the practice space or on another sheet of paper to try these five different styles. Then, try writing some simple words like "joy" and "you" using flourishes on your descender letters. Once you finish practicing, we'll move on to creating our design on the border page.

Our composition grid for this design is a fun one, because it allows us to place some of our words in between the descender flourishes of other letters. It looks like this.

We'll be using four different font styles—Minimalist Print (page 14), Double Trace Font (page 63), Highlighted Letters (page 45) and, of course, our Faux Calligraphy (page 10)—as we position the words in place. Use my sample design as a resource while you're sketching the positions of your words. Notice how "in" and "out" are nestled in between parts of the letters above them. Once your words are in place, you can letter them in marker and erase the pencil lines. Finish up by adding the arrow embellishments to give the design a nice visual balance.

PRACTICE BELOW

CLUBS AND BACON

Straight Line Embellishments

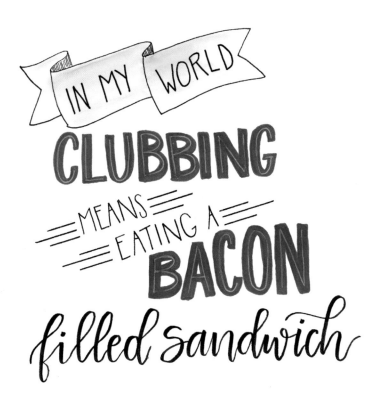

So far, we've looked at a variety of embellishments featuring lines that curve, loop and take on all kinds of decorative forms. But let's not forget that straight lines can be great accents to a lettered design, too! In this chapter, we'll explore several different ways you can use straight lines of different lengths and styles to emphasize a word, fill in empty space or create a modern feel within your projects.

"IN MY WORLD, CLUBBING MEANS EATING A BACON FILLED SANDWICH."

Friends, I think I'm getting old. The idea of getting all dressed up and going out to a club has zero appeal for me. I mean, really. Nothing about that sounds fun. If you do this, can you please explain to me why it's great? I'm genuinely curious, because I'd much rather put on my pajamas and curl up under the covers with Netflix. Truth be told, that scene was never really my thing anyway, and now that I'm a mama in my thirties, I understand it even less. Around here, if you say you want to do something involving me and a club, I really hope you brought bacon. And turkey and provolone and mayo. Or just bacon. It pairs really well with a Netflix binge.

STRAIGHT LINE EMBELLISHMENTS

Grab your ruler and pencil, friend, because it's time to look at how straight lines can embellish our artwork. We're specifically going to be looking at dashes and sunburst effects, but don't limit yourself to just those ideas. There are countless ways lines can be incorporated into a design to take it to the next level.

THREE DASHES

If there's a word or phrase in your design that you want to call a little bit of attention to, one way to highlight it is by drawing three small, short lines on either side. You can keep them all the same length, or you can make the center line slightly longer than the others to create extra visual balance.

Slightly skewing the highest and lowest of the lines so that they're on a diagonal will help draw the eye to the word, as they point in toward it.

SUNBURST

Another great way to emphasize a particular word or drawing is by creating a sunburst effect all around it. To do this, simply draw a series of straight lines beginning next to (but not touching) the object you're highlighting and extending out in all directions like the rays of the sun. You can use as few or as many lines as you like. If you want them to be perfectly straight, feel free to use a ruler or other straightedge as you draw. If you prefer to have that slightly imperfect hand-drawn look, you can draw the lines totally freehand. Either option is fine; it's all about which style you like best.

Varying the length of the lines will give you a totally different look than keeping them all the same. (Here is a little "Easter egg" for my fellow Maryland-ers . . . go Orioles!)

Pro Tip: To help maintain a nice circular shape around the letter or word, pencil in a circle where your lines can originate from.

Another way to add variety to this type of embellishment is by dividing some or all of your lines into shorter line segments. Instead of drawing one continuous line, pick up your pen and skip a little bit of space so that you have a longer piece followed by a shorter piece or two. Here are a few examples of patterns you can create.

— ————— ————— — ———— —— —— —————

When you incorporate these into a sunburst, you'll get something that's visually interesting, like this.

After you play around with these techniques in the practice space, let's put them to work in this quote design. Our composition grid starts with a double banner on a slight diagonal at the top. Then, we have a horizontal line or rectangle for "clubbing," followed by two triangles and one more rectangle.

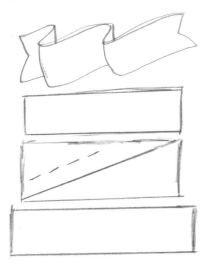

We'll be using Minimalist Print (page 14), Faux Calligraphy (page 10) and Highlighted Letters (page 45) for our words. You'll notice that this time I changed things up a bit by using purple instead of black as the base for my Highlighted Letters. Fit your words into the shapes as always, then trace with marker and color in your banner. Finally, we're going to add straight line embellishments on both sides of the word "means" and the phrase "eating a." This is one great way lines can act as a filler of white space and create balance in a design, don't you think?

PRACTICE BELOW

TRY MY CEREAL
Stretched Script Font

Although brush script is the most popular font associated with hand lettering, there are lots of other cursive fonts you can use to add variety to your artwork. One of these is a style I like to call "Stretched Script," because that's just what it looks like. This font is a thin, elongated cursive that makes even the shortest words take up lots of horizontal space in a design. It's a great choice for making a word look formal but minimal at the same time. In addition to using it within lettered phrases, I often write the name of the person who wrote or said a quote in Stretched Script at the base of the design.

"WHOEVER SAYS I CAN'T COOK OBVIOUSLY HASN'T TRIED MY CEREAL..."

Did you know that if you wait long enough to make dinner and continually answer everyone's food questions with, "I don't know," your family members will go in the pantry and find themselves something to eat? Yes, friends, there is indeed a way to avoid cooking. If you're an anti-chef like me, take note. Your family will not starve. Their self-preservation instincts will kick in and they will raid the fridge and cabinets for whatever is edible. Then, you can swoop in like the hero you are and offer to pour them a delicious bowl of cereal. Everyone likes cereal. And just like that, you've provided dinner for your family yet again. Bravo, mama. Bravo.

STRETCHED SCRIPT FONT

The key to achieving a stretched script is to overemphasize how long and narrow your letters are. Imagine each letter having a long tail on either side of it before it connects to the next letter. I like to use a very fine-tip marker for this font, like a 01 or 03 drawing pen.

Also, you'll want to focus on making the letter itself tight, small and slanted. Here's a look at the word "joy" written in regular script, then in Stretched Script. See what a huge difference it makes?

In addition to using this font all by itself, you can also layer it on top of another style of lettering. In the example below, I simply printed a word in large letters using a Tombow Dual Brush Pen. Then, I wrote over it in Stretched Script.

Here's a look at the lowercase alphabet written in Stretched Script. Typically, when writing in this font, I stick to all lowercase letters because they're smaller than capitals and I like the way it looks aesthetically. However, you can certainly do the same thing with capital letters as well. Try to maintain even spacing between your letters as much as possible. As you practice, you'll start to get a feel for how far to go before starting your next letter.

In this chapter's featured design, we're going to be using this new font style to write the word "obviously." We'll also be using some Faux Calligraphy (page 10) with Bounce Lettering (page 17) as well as Minimalist Print (page 14) and one of our banners (page 49). Start by sketching a slightly arching banner at the top of your design, then four horizontal guidelines for the rest of the words. Here's a quick look at the base of the design.

PRACTICE BELOW

Pencil in your words, then trace with marker, erase the pencil marks and color in your banner to complete your lettered art.

MOM KNOWS BEST

Drawing Magnolias

Just as nature is full of different kinds of flowers and plants, there's no limit to how many different types of botanical images you can create to enhance your artwork. We've already learned how to draw several fancy florals in chapter 5 (page 26). Today, we're going to add a new flower to your repertoire, the magnolia. It's a little more complex than some of our other flowers, but still totally doable. Whether you color it in or leave it as an outline, I think you're going to love the way it looks.

"IF AT FIRST YOU DON'T SUCCEED, LISTEN TO YOUR MOM."

Mothers say a lot of things. And they're almost always right. No matter how much a person might not want to hear it at the time, mom-wisdom is basically infallible. Even if you don't believe it at first. Remember how she said if you made an ugly face it would freeze that way? It didn't right that second, but sure enough if you do it all the time, you'll get the wrinkles to prove it. All those other pieces of advice she gave you? They're true, too. If you really want to save yourself a bunch of time and effort, just ask your mom what to do and then listen. Or you can learn the hard way that she was right all along.

DRAWING MAGNOLIAS

We're going to look at two variations of a magnolia flower, the bud and the bloom. First, we'll learn to sketch the bud from the side as it begins to open. Then we'll move on to the slightly more complicated flower in all its fully bloomed glory. Remember, just like any other illustration, we can break this down into lines and shapes, and you really can do it! Let's get started.

THE BUD

To begin the magnolia bud, we start by sketching a rounded shape that's a lot like an oval but slightly narrower at the top. You'll notice that I'm drawing in pencil first, which is how I recommend you start this illustration, too. Because the petals overlap each other, we'll be erasing some of the lines before we trace over the flower with marker.

Next, we'll draw two petals, one on each side of our original shape. They should start and end at the bottom center of the bud and curve out to either side. The last things we need to sketch are two more petals behind the center of the bud.

Now that the image is drawn, we need to erase the lines we don't want to trace, specifically the two lines from our original shape that overlap the front two petals. Then, we can trace our shape with a marker, color it in and add details. I added three lines in the center and a curving line on each front petal. Now we have a pretty little magnolia that's just about to bloom!

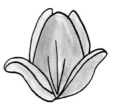

THE BLOOM

For a magnolia in full bloom, we'll start with sketching the center, once again using a pencil. We need to make a triangular shape that's bumpy around the edges and has a small semicircle underneath.

The next step is to sketch the three innermost petals. I personally begin with the back petal, making a leaf-like shape that's wider at the bottom than the top and has a gently curving point. On the left, I draw a wavy petal that extends out to the left. On the right, I start with a line that loops up and over, then I finish the petal with a second line that connects the top to the bottom of the flower's center. If you have trouble creating these shapes freehand, feel free to trace mine a few times until you get a feel for them.

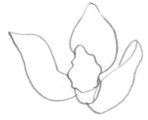

Next, we'll add three more petals. The first is between the petal on the left and the center petal. All you have to do is draw a line shaped like a wide upside-down "v." On the right, you'll draw a petal that starts next to the center petal and ends next to the right petal. I draw a detail line on this one to make it look like it's curving a little. Finally, draw a curving line to represent a petal between the center petal and the one you just drew. Now we have six petals.

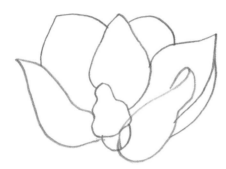

Finally, we add the last three petals. The first one is the trickiest; your line should touch both of the front petals. It's a wide arc and we'll draw a detail line on it to make it look like it's closest to us and curving inward. Then we just need two more petals, one on the left and one on the right, as shown in the example below. Once again, feel free to trace my shapes until you get the hang of how they work.

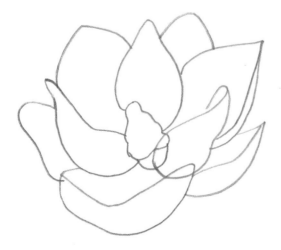

Now that your magnolia is sketched, you'll want to erase any lines that overlap other petals. Then, trace over your illustration in marker and erase any pencil lines you can still see. Finally, color it in! I left this one white, but I colored the center by using the No-Paint Watercolor Technique (page 30) to blend yellow and orange Tombow Dual Brush Markers.

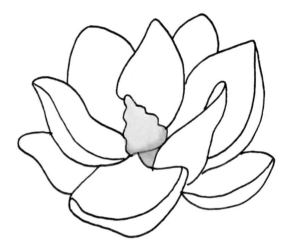

Whether you use them alone or combined with some of your other fancy florals, these pretty flowers add an elegant look to your lettered designs. Since they're so intricate themselves, they make a great focal point, which is how we're going to use them in our featured design.

We're going to keep the lettering itself simple, just five centered lines of text in a combination of Minimalist Print (page 14) and Faux Calligraphy (page 10). Then, below the words, we'll draw a magnolia in full bloom with a bud on either side. Feel free to add leaves, too; magnolia leaves have a very simple shape and are a deep green like the ones you see in my sample image.

PRACTICE BELOW

As always, sketch your guidelines, text and illustration to make sure you like the spacing, then trace with marker and erase the pencil marks. Finally, use the No-Paint Watercolor Technique (page 30) to add a bit of color to your magnolia image. Mom's going to love this one.

MY GOOD PAJAMA PANTS

The Chalkboard Effect

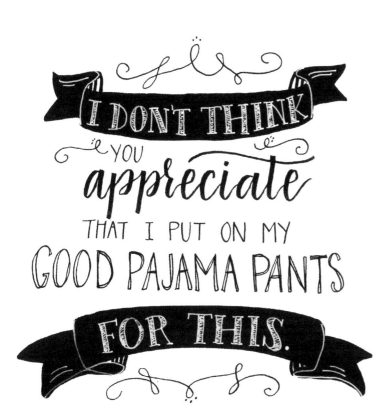

Black or colored lettering plus a white background is always a formula for a great-looking design. However, there's another popular trend in the world of hand lettering and we'd be remiss if we didn't talk about it . . . the chalkboard effect. It's exactly what it sounds like: white lettering on a black background that mimics (or sometimes actually IS) chalk on a chalkboard. You've probably seen this everywhere, and it's such a big deal that there are even books dedicated to nothing but lettering with chalk. Here, I want to talk about the materials that help you achieve this look, both on paper and for projects around your home. Then, we're going to learn a new font that's perfect for your chalkboard-style projects. I think you're going to love this trend as much as I do.

"I DON'T THINK YOU APPRECIATE THAT I PUT ON MY GOOD PAJAMA PANTS FOR THIS."

At my boys' bus stop, we have a rule. It's not even an unspoken rule; my friend Stephanie and I made sure to communicate it loud and clear. The bus stop is a place where moms wear pajamas and occasionally even slippers. We do not brush our hair and we definitely do not wear makeup. There is no judgment at the bus stop, just a mutual understanding that mornings stink and we're doing our best. Real pants are overrated, and there's definitely no need to look fancy when you're busy mom-ing. Parenting is hard, darn it, and life is better in your pjs.

THE CHALKBOARD EFFECT

Chalkboards used to be an absolute necessity in classrooms all around the world. Then, whiteboards took over and the old chalkboards slowly but surely disappeared from view. I think it's our sense of nostalgia that reacted to this change and brought them into our homes as decor so that the look of a vintage chalkboard wasn't lost forever. Essentially, the one thing you have to do to create this effect is letter your design in white on a black background. You can use all the same fonts, embellishments and design layouts you normally do, just as white on black. This style is actually least commonly done with paper and markers; instead, it's usually created on wood or canvas that's been painted black, or on an actual chalkboard surface.

To do this, you can use several different types of writing instruments. Of course, there's always traditional chalk, which obviously gives you the most realistic look, but it's also messy to work with and not as easy to get clean, fine lines. A chalk pencil or chalk marker will give you a look that has some of the characteristics of chalk, but it's easier to control when you write. If you want a design that's permanent and won't rub off when your kids or pets bump into it, you'll want to go with a white paint pen instead. This gives you the look of vibrant white writing on the black surface, but your design will last forever. For more information about these tools and my specific recommendations, check out the Supplies section on page 7.

When it comes to creating a chalkboard effect on paper, we either need to use black cardstock or use a black marker to color in a portion of our design area. For our white lettering, there's nothing better than the Sakura Gelly Roll White Gel Pen. As we saw in the Highlighted Letters Font (page 45), this pen on top of black marker really pops and creates a striking visual effect.

Now that we have our supplies, let's look at a fun font that's a great fit for the chalkboard style. Of course, you can use it in any color and on any background as well, but it's designed to mimic the look of letters written with chalk. The letters themselves are printed, then parts of them get the same double line treatment we give to our alphabet when we're writing in Faux Calligraphy (page 10). So, the first part of forming our letters will feel very familiar!

However, instead of filling in the space between the lines completely, we're going to use short lines or zigzags that allow a little bit of the background to show through. This is intended to look like the textured, imperfect look you get when coloring with real chalk.

The final difference between this process and our Faux Calligraphy is that we're going to add serifs to the ends of these letters. This enhances the vintage vibe of chalk lettering.

Here's what the letters will look like when they're written on the black background.

For your reference, here is the entire uppercase alphabet and numerals in this chalkboard font. You'll notice that it still looks great, even when written with black or another color on white.

ABCDEFGHIJKL
MNOPQRSTUV
WXYZ 0123456789

Typically, I tend to use all caps for this font, paired with a lowercase script. However, there's no reason you can't use this style for lowercase print. Here's the alphabet written that way so you can refer to it as a guide.

abcdefghijklmn
opqrstuvwxyz

Have some fun practicing this new lettering style in the practice space, then let's head over to the border page to create our special design! In order to use the chalkboard-style letters in true white-on-black format, we're going to start by sketching two banners (page 49) and coloring them in completely with black marker. One will be on the top of our design, and the other will go at the bottom. Between them, we'll have straight horizontal rows of text, so you'll want to sketch those guidelines using a pencil and a straightedge. Here's a look at the grid behind the design.

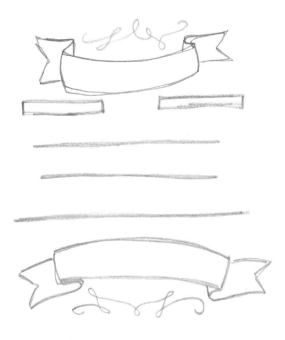

Pencil the words, "you appreciate that I put on my good pajama pants" in the center of the design in a combination of Minimalist Print (page 14), Faux Calligraphy (page 10) and Double Trace Font (page 63), or any other styles you choose. Then, trace over them with marker. Next, it's time to add your new Chalkboard Effect font on top of the black banners by writing with a white gel pen. Finally, add a few stand-alone flourishes at the top, bottom and sides of your design.

PRACTICE BELOW

SINGLE SOCKS

Simple Brush Technique

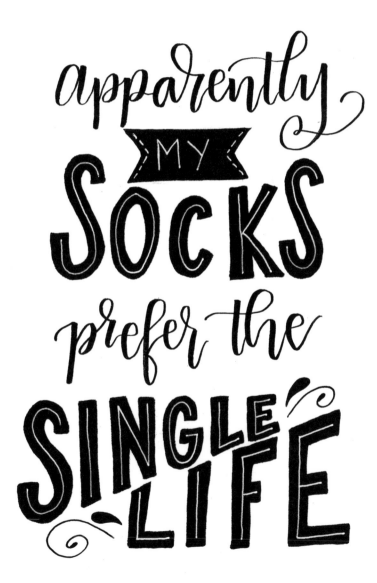

By now, you've got lots of experience with the art of Faux Calligraphy (page 10), which allows you to get the look of brush lettering with any type of pen, pencil or marker you have. Now, it's time to take things a step further by learning how to do real brush lettering, an art form that allows you to create thick and thin lines based on the amount of pressure you apply to a brush or brush pen. This can be a tricky skill to master, and takes lots of time, practice and patience. Don't be discouraged if it doesn't come as easily to you as the other skills we've worked on so far. It also requires a special type of pen, one specially labeled as a "brush pen" or "brush tip." Some of my favorites are the Tombow Fudenosuke, the Pentel Sign Pen with Brush Tip and the Tombow Dual Brush Pen. As you head into this tutorial, you'll want to make sure you have at least one of those markers on hand. If you've already tried your hand (literally) at this technique, you can use this chapter as a refresher and an opportunity to refine your skills. Ready? Let's jump in!

"APPARENTLY, MY SOCKS PREFER THE SINGLE LIFE."

I will never understand the mathematical magic that happens inside my clothes dryer. For every two socks I put in, only one comes back out. This leads to drastic situations, like boys who are panicking and running around with one sock on and one bare foot five seconds before the bus comes. I'm not exactly sure what the socks' agenda is. Perhaps they simply prefer the single life. Maybe they're part of a plot designed by retailers to increase sock sales. The most logical scenario I can imagine is that they sneak out and party with Tupperware lids in an undisclosed location. Whatever the case, it's clearly me versus the socks, and I'm afraid they're winning.

SIMPLE BRUSH TECHNIQUE

You are a step ahead as you begin this brush lettering tutorial, because you already know the single most important rule: downstrokes are thick, and upstrokes and horizontal strokes are thin. All that's left is to figure out how to create those two different kinds of strokes with a brush pen. Right now, I want you to pick up whatever brush pen you've chosen to work with and press the tip of it against the page. Notice how it bends? That's what makes brush pens different from bullet tip and other types of markers. The tip is flexible, designed to mimic the properties of a paintbrush. Depending on the way you hold the pen and how much pressure you apply, you will be able to create lines that look very different from one another.

STEP 1

Start with a downstroke.

Place your pen on the page and pull down toward yourself while applying pressure. I tend to hold my pen at about a 45-degree angle to the paper when I make these downstrokes. That allows you to write with the side of the brush tip rather than just the point. You should get a dark, thick line. Don't be afraid of hurting the pen; it's designed to do this, I promise. Then, repeat that process and make a row of lines that look like my examples below. If you've already experimented with this technique, my challenge for you is to try to keep your pressure as consistent as possible so that all of your lines have exactly the same thickness.

STEP 2

Draw an upstroke.

In contrast to the downstrokes, our upstrokes should be much lighter and thinner. To create these, you'll touch just the tip of the pen to the page and gently flick your wrist up and away from yourself. You just want the pen tip to skim the page with the lightest possible pressure. Make a row of these lines now. All of your upstrokes should look similar to these. Experienced brush letterers, once again I'd challenge you to keep the width of these lines as consistent as you can.

STEP 3

Now, try alternating those strokes.

When you feel confident, try alternating without picking up your pen, which will create a squiggle. Those of you who have lettered before should focus on clean transitions from thick to thin, which means gradually increasing and decreasing pressure rather than doing it abruptly. The thick lines should flow seamlessly into the thin ones without one visible spot where you suddenly changed pressure.

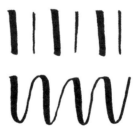

Writing with Brush Technique simply means applying these skills to every letter in the alphabet. Every time your pen is moving down while you write, you'll want to apply pressure and create a thick downstroke. When the pen is moving away from you, release the pressure and let the stroke stay thin instead. It's definitely easier said than done; as I mentioned in the introduction, it takes time, patience and

repetition to get the hang of turning these strokes into letters. The good news, though, is that once you master the feel of it, your muscle memory will kick in and you won't even have to think about it anymore.

Here is a sample alphabet written in Brush Technique. It looks very similar to our Faux Calligraphy alphabet (page 11); the difference is just in how we achieve the different kinds of strokes.

Aa Bb Cc Dd Ee Ff
Gg Hh Ii Jj Kk Ll
Mm Nn Oo Pp Qq Rr
Ss Tt Uu Vv Ww Xx
Yy Zz 0123456789

You may be wondering why this is called "Brush Technique" when it's done with a marker. The reason is that the marker's tip is actually designed to mimic the action of a small, thin paintbrush. In addition to using the markers I recommended, you can take this technique a step further and challenge yourself by trying it with a real brush. You'll want to find something called a liner brush, which has long, thin bristles, and some watercolor paints. I recommend hot press watercolor paper as a surface, as well as the pages in this book. Load your brush with paint and try making the practice strokes that way. Just as you did with the marker, you'll want to control the thickness of the strokes by applying or removing pressure on the brush. Most artists, myself included, find it more difficult to control a paintbrush than a marker, but it's definitely doable. Learning to letter with a brush is a really useful skill for when you want to create on non-paper surfaces like the projects you'll find in the back of the book.

Take some time practicing the basic strokes using a marker as well as a brush if you like, then try using the technique to write some of the words from this chapter's quote. When you're ready, head on over to the border page to create our design.

Here's the composition grid we'll be using for the layout.

After you pencil in the basic shapes, use the Brush Technique to letter the words "apparently" and "prefer the." The rest of the words will be in Highlighted Letters Font (page 45), except for "my," which goes inside the banner (page 49) in Minimalist Print (page 14). Then, it's time to do your lettering in marker, including the Tombow Fudenosuke or another black brush pen for your Brush Technique.

WHO WANTS KALE?

Working with Wreaths

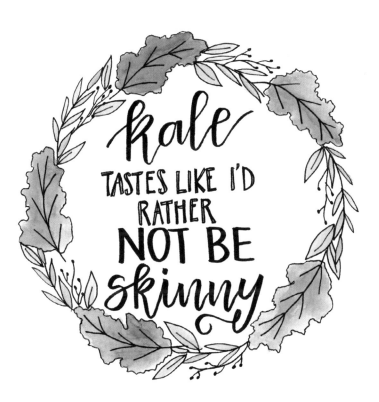

By now, you've become a pro at drawing pretty botanical sketches to accent your lettering. Now it's time to take them one step further by shaping those individual plants and flowers into wreaths. These make a gorgeous border for a lettered quote, monogram or word, and they're easy to customize depending on what specific botanicals you decide to draw. Pine and berries are great for the holidays, while bright blooms are perfect for spring and summer designs. Here, we're also going to add a special little touch to ours by adding everyone's un-favorite leafy green, kale, to the mix to go along with our featured quote. If it can't be tasty, we can at least make it pretty, right?

"KALE TASTES LIKE I'D RATHER NOT BE SKINNY."

Apparently, kale is a superfood. I do not understand this at all. In fact, I'm not even sure that I think kale *IS* food. If you want to talk about superfoods, let's talk about foods that are, in fact, super. Pizza, for example. Chinese food. Ice cream. How about stuffed shrimp or tacos? Then there's brownies, cupcakes, Nutella on a spoon . . . I have a whole list. Kale is not on it. Kale is a leaf. If eating kale is what it takes to be skinny, the cost is just too great. I'll just be over here eating my own superfoods. I might not be thin, but I'll be happy!

WORKING WITH WREATHS

To illustrate a wreath, the first thing we need is a circle. I typically look around the house for something that's the right size for my design, like a coffee mug or a small bowl, and lightly trace it onto the paper. This will be the base for your wreath. All that's left is to draw the plants, flowers and leaves of your choice around the traced shape. Before we do that, though, let's take a look at a few types of leaves and branches you can use.

BASIC LEAF

This shape is basically just an oval with pointed ends. You can leave it as is, or you can add details such as a line through the center or many small veins.

By changing the height and width of the shape, you can make this same basic doodle look like completely different leaves. You can also change the look by adding veins of different lengths and spacing.

LEAFY BRANCH

Start this by drawing a line for the branch's center. It can be straight or curving, and as long or short as you like. Then, add leaves on either side of the branch. Depending on the size and shape of the leaves, once again you can get quite a variety of plants.

PINE BRANCH

This is similar to the leafy branch, but rather than drawing leaf shapes, you'll want to draw short, straight lines to represent pine needles. If you like, add some color to make it look more realistic!

BUDDING BRANCH

This is one of my favorites. Sketch a line for the center of the branch, then go back and draw several other lines coming off of it. Allow those to split off into smaller branches of their own as often as you like. Top off the lines with tiny circles or flower buds.

KALE

In honor of our silly quote, we also have to add one last plant to our wreath today: kale. To draw this supposed "food," you'll want to start with a center line and three or four "v" shapes. Then, you'll go around the edge drawing a very bumpy border to represent the way a kale leaf curls at the edges. Color it in, and *voilà*!

Now, it's time to sketch a combination of your favorite plants and leaves around the circle you created. Don't worry about them touching each other; in fact, you want them to overlap so it looks natural. You can just fill in as you go, but I personally like to start with one leaf type and sketch it in various spots around the wreath, then repeat with the next type and so on until the circle is full. I find it helpful to start with the larger leaves, as they take up more space, then fill in the remaining spaces with the smaller types. This helps ensure that different kinds of plants are spread out all over the wreath.

Sometimes I place all the leaves going in the same direction, while other times I will point some going the opposite way for visual interest. There's no right or wrong way to do this; each creates a different effect and you can choose whatever you like best.

It's totally up to you how small or large your wreath is and how many types of plants you want to use.

Feel free to experiment with different combinations of leaves and flowers, including the magnolias (page 88) and fancy florals (page 26) we learned in earlier chapters too. When you have a wreath you like, trace the outlines in a thin black marker, then fill in the leaves and flowers with color.

Then, when you're ready, you can move on to creating your finished design on the border page. I suggest that you start by penciling in guidelines/shapes for your lettering and completing the quote first, then sketching your circle around it. This way you'll know the quote is centered and fits well inside. I used a combination of Faux Calligraphy (page 10), Double Trace Font (page 63) and a thick print, but you can write in any styles you prefer. Finish the design by drawing your plants and leaves, then coloring them in using the No-Paint Watercolor Technique (page 30). Wouldn't this look perfect framed and on display in the kitchen? You know, to look at while you're stuffing your face with pizza like I do at least once a week . . .

PRACTICE BELOW

LET US EAT CAKE

Filler Flourishes

So far, we've learned to use flourishes in several different ways: standing alone, attached to ascenders and descenders and crossing our "t"s. But did you know that flourishes can also make a great pattern to fill large sections of empty space? Combining several variations of swirls and loops and repeating them close to one another is a great way to add whimsy and color to an otherwise blank section of your design. In this chapter, we'll take a look at how to create this type of pattern, then you can practice using it as a filler while you letter a festive quote on the border page.

"TODAY IS SOMEONE'S BIRTHDAY... HAVE SOME CAKE!"

There are 365 days in a year. As I write these words in June 2018, there are 7.6 billion people living in the world. That means, on average, there are 20,547,945 people having a birthday each day. Of course, there's some give and take, but I think it's safe to say that every day is definitely someone's birthday! More like twenty million "someone"s! If that's not a reason to celebrate, what is? I think it's safe to say we ought to party. I mean, not for our own sake, of course, but for those millions of people who need to feel celebrated and important! Eating a piece of cake is just our small way of saying "cheers" to the birthday boys and girls around the world today. Being a good human isn't always easy, but someone's got to do it. Can you please pass me a fork?

FILLER FLOURISHES

In order to create our pattern, we'll be using a combination of three basic kinds of swirls. The first is a simple spiral. The second is a spiral with a "v" on one side. I usually start with the "v" part and then end with the spiral. There's also a basic loop followed by a spiral. Practice making these basic shapes, then try making them facing all different directions. Try them backward, upside down and sideways until you're comfortable with them.

STEP 1

Create a border.

Use your spirals to create a border around the edges of your paper or whatever shape you want to create.

STEP 2

Fill in the center area with more of the swirl shapes.

You'll see I used a combination of all three shapes going in all different directions. There is no right or wrong way to do this—just fill the space.

STEP 3

Add accent lines.

To create the accent lines, I just make a shorter line that follows the curve of the original one. It can go outside the original one, inside of it, or both. You can see where I started to do this in the top corner of the design. Again, there's no right or wrong to where or how many of these you draw.

I used a second color here to show you where the accent lines are. When I do a design like this, I typically end up using four or five different colors. If you prefer, though, you can do everything using the same marker or pen. Play around with different color combinations, because you'll get totally different effects!

STEP 4

Add a series of dots.

Use a marker with a nice round tip so that you can dot with one tap rather than having to draw a bunch of tiny circles. I like sets of three dots, but sometimes I'll use just one and occasionally I'll use five in a row. In design, odd numbers always look best. Let your dots follow the curves of your swirls.

STEP 5.

Add teardrop shapes in any open spaces.

If you prefer, you can use another shape instead, like a heart, a star or a larger circle. This is basically a space filler, taking up any large spots of white space that remain after your swirls and dots are complete.

See how easy it is to fill a whole space using swirls and flourishes? Of course, this exercise is just one combination; you can pick and choose whatever you like best to fill your space. Using just a few of these things will give you a different look than if you use them all. The teardrops add a whimsical vibe, while all flourishes can look very elegant. Take some time to try this technique in the space to the right. The shape we'll be filling for this chapter's design is a balloon. When you're ready, sketch a large oval with a triangle at the bottom. Next to it, you'll pencil in five horizontal guidelines for your lettering.

PRACTICE BELOW

The words "birthday" and "cake" will be in Faux Calligraphy (page 10), while the rest of the words are Double Trace Font (page 63). I colored in the open spaces of the Double Trace letters to add a pop of color that coordinates with my filler flourishes. Trace the outline of the balloon and fill the inside using the technique we just practiced. Finish off the design by creating a looping balloon string that borders the side and bottom of the quote. Now you're ready to party!

CRUEL AND UNFAIR PUNISHMENT

All Mixed Up Font

Part of the fun of being an artist is that you don't always have to follow the conventional rules of writing, including capitalization. You can use a font that's entirely lowercase or totally comprised of capital letters if you like, and what's even more fun is that you can use a combination of both in any given word. In this chapter, we're going to look at a font that allows you to use a mixture of uppercase and lowercase letters that adds a whimsical look to your art. Ready to get started?

"APPARENTLY, YOU HAVE TO EXERCISE MORE THAN ONCE TO GET RESULTS... THIS IS CRUEL & UNFAIR."

Recently, I decided it was time to do something about the extra weight I put on during our adoption process. (Stress eating gets me every time!) First, I skipped my sugary cereal and ate yogurt for breakfast instead. Then, I had a small lunch and went for a walk. I even picked up my feet a little faster than normal. I wouldn't say it was running, per se, but I was definitely working harder than usual. I opted not to have ice cream after dinner, and at the end of the day, I felt great about my choices. I stepped on the scale and . . . it was exactly the same. All that work and for what? Nothing! Totally unfair. I think ten pounds should have magically melted off in celebration of my effort and good intentions, don't you?

ALL MIXED UP FONT

My favorite thing about the All Mixed Up Font is that there are literally no rules! You can use any combination of lowercase and capital letters you like to create a totally unique look. You can also vary the sizes and positions of the letters when you write your words so that they aren't sitting straight on the baseline. Take a look at the same word written on a line, then written with bounce.

PaTieNce
PaTieNce

One way to decide which letters to capitalize is to make a rule like "vowels are lowercase and everything else is uppercase," or vice versa.

If you're choosing to give your letters some bounce, you can also look at the letters in your word and try fitting them together like a puzzle. Tuck smaller letters into the spaces left by larger ones, using the natural shapes of the letters to help you figure out where they should go.

LeTTeRiNG CaN Be LiKe a PuZZle... fiT everyThiNG ToGeTHer!

If these kinds of loose instructions work for you, you're ready to go for it and get started with your practice by writing a few words in this style. However, for many folks, rules are actually helpful and so are visual guides. Here is a sample alphabet written in the All Mixed Up Font that you can refer to if you like. Feel free to change things around and make it uniquely yours as you get more comfortable. For bonus visual inspiration, check out Instagram artist Amy Reid @sweetpreciousletters, who rocks this style like a boss.

aBcdeFGhi
jKLMNOPq
RSTuvwX
Yz 0123456789

Take some time to write your name and a few other words using this new font. Play around with capitalizing different letters and looking at how your letters fit together next to one another. This font should have a very playful style that still looks cohesive even though it's a mixture of different things. Then, let's hop over to the border page and put it to work in our featured quote design.

The first step you'll want to take is sketching seven horizontal guidelines for your lines of text. Next, pencil in the words, using my sample as a guide. I chose to combine this new font with Minimalist Print (page 14) and Faux Calligraphy/Brush Technique (page 10/page 98). Trace over your lettering with markers, then it's time to add embellishments. Sketch, then trace two weights; all you have to do is draw parallel lines with circular shapes on the ends. Color them in, then finish up by adding a few straight line embellishments (page 80) on either side of the top word. If only exercising were as easy as writing about it, right?

PRACTICE BELOW

MY PERSONAL STYLE

Finding Your Own Style

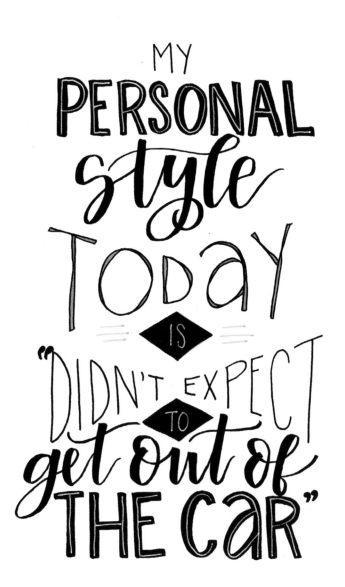

One of the questions I'm asked on a regular basis about hand lettering is, "How do I find my own style?" At first, I wasn't sure how to answer, other than, "Over time, you just . . . do." But I realized that's not at all helpful! So, I thought it was time to sit down and come up with something that would really guide you on your way to discovering your own unique lettering style. While all of us use the same basic techniques, our lettering should be as individual as we are! I realized that when we letter, we make lots of choices, and the combination of those choices creates our style. Let's jump in and take a look at five of those important decisions today.

"MY PERSONAL STYLE TODAY IS 'DIDN'T EXPECT TO GET OUT OF THE CAR.'"

We've all had those days, right? You know, the kind where you hit the snooze button one too many times, the shirt you wanted to wear isn't clean and the kids are running late for school. Those are the days when you just keep your pajama shirt on, throw on a pair of sweatpants and shove a hat over your bed head before jumping in the car. And inevitably, they're also the days when you run into everyone you know. What is that about? You plan to stick to drive-throughs and carpool lines, but something happens and you have to actually step out in public and be seen. It's like the universe knows and is playing a joke on us! Next time I see you with no makeup and yesterday's hairstyle, I promise not to notice, if you'll promise to ignore my pj shirt, too.

FINDING YOUR OWN STYLE

First, we need to define what makes up our style. Although there is definitely a "correct" technique to brush lettering, as we discussed in chapter 21 (page 98), everyone's lettering is unique, just like our handwriting. While your style may have reflections of other artists, ultimately it should be distinctly your own. My hope is that when someone who knows my work is browsing the great wide web or their local bookstore and comes across one of my lettered designs, it would be instantly recognizable as mine.

In order to develop a style, we first have to figure out what the pieces are. What I've concluded is that your lettering style is essentially a combination of the decisions you make in the following five categories.

LETTER SHAPES

The thing that will differentiate your style more than any other component is the way in which you choose to form your letters. All (good) brush lettering will have thick downstrokes and thin upstrokes, but there are an infinite number of ways to write any given letter. In fact, there are practice sheets all over the internet for various ways to form an "A," a "B," etc. Of course you might experiment with different shapes sometimes, but in general, you will have a particular way you like to write each letter.

Take, for example, the letter "b" in my illustration below. Notice how whether I'm writing a normal or a more embellished "b," I always start by moving my pen upward? The third example, where the tail begins by going down first, then back up, is something you wouldn't see in my work because that's just not how I write my "b."

Take a look at these "r"s. No matter what design I'm creating, if I'm using brush lettering, my lowercase "r" will always have a loop on the left side, because I like the look of it. If you see an "r" without a loop like the one on the right, it isn't my lettering. It's not that one way is right and the other is wrong; it's all a matter of personal preference.

Over time as you practice letter shapes, you'll find that you like certain things better than others and you'll end up with a default alphabet. Although you might sometimes embellish your letters or do something different because of a particular design, in general your style will be composed of your own favorite version of every letter.

STYLE HOMEWORK

On a sheet of sketch paper, write each letter of the alphabet in Brush Technique (page 98).

Don't think too hard about it—just write. This will show you what your muscle memory is for each letter. Look at the letters and see if you like the way they're styled. If not, explore some practice sheets and tutorials and look on Pinterest to see other ways you could style them. Then, on a new sheet of paper, write your own ideal lettered alphabet with each letter just the way you like it as a resource. When you create a design, practice forming the letters that way so that the new shapes become your muscle memory.

SLANT

When we write, whether we think about it consciously or not, we give a particular slant to our words. The way we hold our paper and pen affects this, as well as whether we are right- or left-handed. Some artists write straight up and down, while others slant more or less in either direction. I tend to slant my words just slightly to the right like the first example below. My actual everyday cursive handwriting tends to slant much farther to the right than my hand lettering does.

As with our letter shapes, there is no "right" or "wrong" to how much slant someone's lettering has. It's all a matter of the artist's preference and habits.

STYLE HOMEWORK

Take a look at something you have lettered to see what type of slant you naturally apply.

If you find that you like the look of designs with more or less slant, you can teach yourself to write that way. Often, the easiest thing to do is to change the way you position your paper. Play around with it until you find something that's comfortable and that appeals to you.

BOUNCE

Back in chapter 3 (page 17), we learned how to put bounce in our lettering, rather than having all our letters sit on a straight baseline. Every artist has a slightly different idea of how much bounce he or she likes to use. Some folks like to keep things straight and neat with basically no bounce at all, like the first example below. Others enjoy taking a walk on the wild side and having their letters at many different heights, like the third example. Personally, I usually fall somewhere in between. You'll notice in the second example that the first letter is on a baseline, the second drifts up above it and the third comes down just a bit below the original baseline. There's enough bounce to keep it interesting, but not as much as some artists use.

STYLE HOMEWORK

Letter your full name on a sheet of sketch/scrap paper.

Now, take a look at how your letters line up. Are they straight, or do they bounce freely around the page? If you started by looking for lined paper or drawing a pencil line with a straightedge, chances are that your style is going to have no bounce! Which is totally awesome, by the way . . . remember, there's no right or wrong to style. If you're lazy like me and don't want to worry about whether your words are straight or not, a little bit of bounce is the perfect solution.

SPACING

When we write, we automatically leave a certain amount of space in between our letters. It's not always precisely the same—that's one difference between something done by hand and a typed font—but in general it's pretty uniform. Otherwise, our words would look awfully strange! What many folks don't realize is that by leaving more or less space between our letters, we can drastically change the way our lettering looks. In the example below, I used the same letter shapes, the same slant and the same pen for all three words, but they look totally different. In the first one, I used my own natural amount of spacing. In the second, I increased the space between the letters, and in the third example I decreased it.

As with all of the other elements, each of the three amounts of spacing is "correct." It's a matter of how you like your writing to look. Some artists prefer their words to be compact, while others love to elongate words for an elegant appearance. As long as you keep the spacing consistent within the word, you can leave as much or as little as you like.

STYLE HOMEWORK

Write the word "write" on your sketch paper.

Which of my examples does your word most closely resemble?

Now, try writing it with more or less space between your letters. You'll find that you really have to think about it to change your spacing, because it's an ingrained habit. Do you like one of the other looks better? Experiment until you find something that looks and feels great.

CONTRAST

The final piece of the style puzzle has to do with the contrast between the up- and downstrokes in your lettering. We know that upstrokes are thin while downstrokes are thick, but the amount of contrast between your thick and thin lines can completely change the look of your lettering. Look at the three examples below. The letter shapes, slant, bounce and spacing are all consistent, but I used a different size brush tip for each one.

The amount of contrast actually has more to do with which tools you use than anything else. If your favorite marker to use is the Tombow Dual Brush Pen, your work likely looks more like the third example because the marker tips are large. If your default lettering tool is the Tombow Fudenosuke or Pentel Sign Pen, you probably find that your lettering looks more like the first example. Your favorite tools will determine your contrast simply based on the size and flexibility of the brush tip. You do have some artistic control, though, when it comes to how much pressure you apply. The harder you press, the thicker the line, and the lighter the touch, the thinner your upstroke will be.

STYLE HOMEWORK

Gather three to five different types of markers and use them to write the same word.

Look at the difference in how the word looks even when nothing else about your style changes. Which look do you like best? Which tools allow you to create that look?

To review, these are the five pieces of the puzzle to creating your own lettering style: LETTER SHAPES, SLANT, BOUNCE, SPACING and CONTRAST. Your own unique combination of these five things will define your style and set it apart from anyone else's.

As you're developing your style, you'll definitely want to look at other artists' work on Pinterest, blogs, Instagram and anywhere else you can to see all kinds of examples. As you do, you'll find certain things you like better than others, and things you want to emulate in your own lettering. You certainly don't want to be an exact copy of another artist, but chances are, your style will have traces of the people you learn from and admire. In mine, I see certain shadows of my first "teacher," Dawn Nicole, as well as other lettering friends whose work I love.

As you look at examples, the next step is to try everything! Set aside a sketchbook just for playing around with new flourishes, fonts and techniques. See what works and what doesn't. As you do, you'll start to find yourself gravitating toward a certain style.

This chapter's featured quote is a perfect place to start. Here's a look at the grid I used for the sample at the beginning of the chapter. But play around with the design, trying different tools and different combinations of shapes, slant, bounce, spacing and contrast.

Feel free to use it to inspire your creation, or to make something totally unique! See what you like best, then finalize your design on the border page.

I'D RATHER SIESTA THAN FIESTA
Creating Cacti

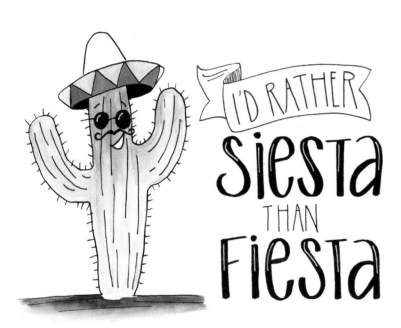

I'm sure you've noticed that cacti aren't just found in the desert anymore. Whether it's on clothing, dish towels, cards, wall art or accessories, cacti are popping up everywhere, bringing color and fun with them. It should be no surprise, then, that learning to draw a cactus is a useful skill in your hand lettering journey, too. Not only is it a great way to embellish any quote about nature, but a cactus can also be used to accompany all kinds of "punny" lettering, like, "stuck on you," "we stick together" or "free hugs." We're going to focus on two particular types of cacti in this chapter that you'll be able to incorporate into your designs whenever you like.

"I'D RATHER SIESTA THAN FIESTA."

When I was younger, I was always up for a party. Weren't you, too? Good friends, good food, good times. What could be better!? But the older I get, the less I'm inclined to feel that way. I've got ice cream in the freezer, movies on demand and by 10 p.m., I'm thinking more about my pillow than anything else. A great party might have a lot to offer, but so does a nap! I mean, really, which sounds better to you? These days, I appreciate the invite, but truth be told, I'd rather siesta than fiesta. Don't be offended; it's not that I don't like you. I just like sleep more.

CREATING CACTI

Like any plant or flower, there are many types of cacti. In this chapter, we'll be learning to draw two of the most well-known kinds, the prickly pear cactus and the saguaro cactus. We'll also look at how to add a few accessories to give them some personality. Let's start with the prickly pear.

PRICKLY PEAR CACTUS

If you can draw simple shapes like circles and ovals, you'll have no problem drawing this type of cactus. Start by sketching a large oval shape that's slightly smaller at the bottom. Make the bottom flat so that it looks as though it's sitting on the ground or in a pot.

Next, sketch two smaller oval shapes sitting on top of the large one. Continue sketching smaller ovals branching off of each other in any pattern you like. You can make some of the shapes longer and thinner, and others more rounded.

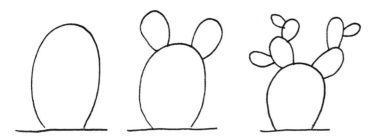

Using a very fine marker, like an 01 or 03, draw short straight lines to represent the spines of the cactus. Go around the outsides of your shapes as well as drawing some on the insides. I like to draw some single lines and others as pairs in the shape of a "v."

Then add a few tiny teardrop shapes to the top ovals. These will be the blooms. All that's left to do is color in the image using our No-Paint Watercolor Technique (page 30).

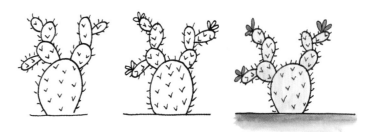

That's all there is to it! Now let's look at another type of cactus, the saguaro.

SAGUARO CACTUS

When you hear the word "cactus," this particular type is probably the first image that comes to mind. It has a tall, straight center with several branches going off to the sides. Often, you'll see it represented with one branch on each side of the main "body," which is how we're going to draw it today. We're going to start by sketching the center part of the plant, which is a long, thin oval. You'll want to do this with pencil first.

Next, we'll add an "arm" to each side. These should branch off at slightly different heights. They can be similar in size, or one can be larger than the other. Then, we'll erase the pencil lines where the branches connect as well as the bottom of the main oval. You may want to draw horizontal lines on either side of the cactus to represent the ground.

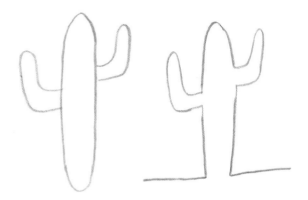

All that's left is to add detail. First, we'll draw some long, thin lines to show texture. Make sure the lines follow the same curve as the branches. Then, we'll add short, straight lines for the spines.

When the detail work is done, use the No-Paint Watercolor Technique to fill in your shape with a shade of green.

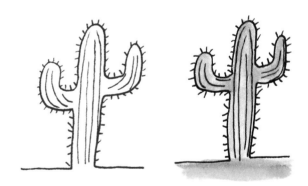

MAKING A CARTOON

Sometimes we'll want the more realistic version of our cactus in our lettered designs, but other times we might prefer to give our plants a personality. By adding a few basic accessories, we can create a real character. Our quote about siestas and fiestas is just begging for a Mexican cactus wearing a sombrero and shades, don't you agree? To create a sombrero, all you need to do is draw a small upside-down "u" shape sitting on a curving line. It will look a little bit like a sunrise.

Then, add a second line below the first that's slightly shorter. Connect them with short vertical lines. Feel free to add any pattern you like to the hat, or to leave it plain.

Sunglasses are nothing more than two simple circle or oval shapes connected with short, straight lines.

Add any other details, like a smile, a mustache and some eyebrows, and your cactus has a personality all his own! Color him in and he's ready to embellish any design.

Pencil in your words using my sample design as a guide, then trace everything with marker and color in your design using the No-Paint Watercolor Technique (page 30) or anything else you have on hand. *Olé*!

PRACTICE BELOW

Speaking of designs, we're going to keep this one simple text-wise because our focus is on Señor Cactus. If our design is too busy, it'll distract from our illustration. To letter the phrase, we're going to combine Minimalist Print (page 14) and the All Mixed Up Font (page 114). Use the practice space to practice your cactus creations, then get started with your design on the next page. Draw your cactus to the left, then on the right you'll be sketching a banner (page 49) with three horizontal lines below it.

FRACTURED MOTIVATION

Adding Color in Your Words

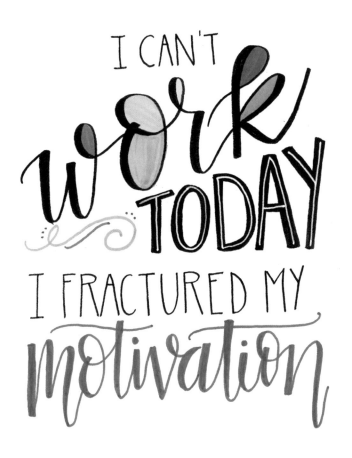

There are many ways to add color to your hand lettered art, including writing with colored markers and using the No-Paint Watercolor Technique (page 30) to fill in embellishments and drawings around your words. In this chapter, we're going to look at one more method that adds a fun touch to your lettering and creates a style all its own. Choose a few of your favorite colored markers, along with a black one, and we'll get started.

"I CAN'T WORK TODAY. I FRACTURED MY MOTIVATION."

Have you ever had one of those days where your "get-up-and-go" got up and went somewhere else? You know, the kind of day when you want to call out of work but you don't have a good reason? I mean, most bosses are sympathetic and understanding when you say you can't come in because you have the flu, but they're not overly fond of the excuse, "I'd rather stay in bed and watch all eight seasons of *Psych*." That's why I think there should be two kinds of sick days: one for physical illnesses and one for days when you just can't do all the things. Those days, we can tell our bosses we fractured our motivation or that we've developed a rash of unproductivity. Perhaps we are feverishly avoiding work. Whatever the specific ailment, I think it's a totally legit reason, don't you?

ADDING COLOR IN YOUR WORDS

No matter what font you happen to use, there will be certain letters with enclosed spaces inside. Adding color inside those spaces is a great way to brighten up your lettering even without adding embellishments. All you have to do is letter your word normally using a non-water-based marker, like a Tombow Mono Drawing Pen or a Sakura Micron. Then, go back and fill in the enclosed spaces with the colors of your choice. To help enhance the look of this alphabet, you might want to exaggerate the size of your enclosed spaces a bit, making them larger than usual so there's plenty of area to be colored.

You can stick with the same color throughout an entire word or phrase, or you can randomly alternate colors for a cheerful, whimsical style. For a great example of this, check out my friend Dio Perez, aka @paisleyinparis, on Instagram. She uses this technique often in her bright, beautiful work!

Here are samples of both an uppercase and a lowercase alphabet using this technique that you can use for reference and inspiration. Don't let them box you in, though—you can do this with any font style you can imagine, including everything you have learned in this book so far!

Aa Bb Cc Dd Ee Ff Gg Hh
Ii Jj Kk Ll Mm Nn Oo Pp
Qq Rr Ss Tt Uu Vv Ww Xx
Yy Zz Aa Bb Cc Dd Ee Ff Gg
Hh Ii Jj Kk Ll Mm Nn Oo Pp Qq
Rr Ss Tt Uu Vv Ww Xx Yy Zz 0123456789

Have some fun playing around with this technique in the practice space. Try writing your name, along with any other practice words you like. Remember, you can use whatever font you want, so try this with Faux Calligraphy (page 10), All Mixed Up (page 114), Double Trace (page 63) and more to see what your favorites are. Then, we'll move to the border page to create this design.

First, you'll want to sketch your composition grid with pencil. Mine looks like this.

Next, sketch the positions of your words. "I can't" goes on the first line in Minimalist Print (page 14). "Work" is written in either Faux Calligraphy (page 10) or Brush Technique (page 98) on the diagonal, nice and large because it's the focus of our quote. Below that in the triangle, use the Highlighted Letters Font (page 45) for the word "today." We'll sketch in a little looping flourish (page 39) to fill the rest of that space under the "w." Finally, "I fractured my" goes on the next line in Minimalist Print, and "motivation" finishes things up in Faux Calligraphy/Brush Technique on the final line. Once you've worked out the positioning of all your words, it's time to finalize everything with markers. I did all the lettering in black except for "motivation," but you can choose whatever colors you like best. Then, I went back and added a variety of bright colors to the spaces in the word "work," just like we practiced in this chapter. As always, you can feel free to copy my design exactly or to change it in your own unique ways. No matter how you do it, it's better than working, am I right?

PRACTICE BELOW

CAN'T REACH THAT

Bujo Borders and Line Designs

"Bujo" is short for "bullet journaling," which is quite a popular thing right now. Personally, I keep my calendar on my phone, but I do think anything that encourages people to use handwriting and doodles is fabulous. Do you bujo? If so, keep up the great work and do a little for me, too. Even if you don't happen to bullet journal, an interesting line design can enhance any piece of lettered art. In this chapter, I want to give you a few quick and easy ideas you can master in no time at all, so pick your favorite fine-tip marker and let's bu-go!

"YOU REALLY HAVE TO HAND IT TO SHORT PEOPLE. IF YOU DON'T, WE CAN'T REACH IT!"

Being short is a giant pain. Seriously. If you are vertically challenged like I am, you're probably nodding in agreement because you know firsthand all the things that are just harder for us than for our tall friends. When I'm unloading the dishwasher, I have to wait for my husband to put certain coffee mugs and dishes in the cabinet. I've learned to like the food that's on the lower shelves at the grocery store, because I can't reach anything at the top. I have never seen the top of the china cabinet or the refrigerator. I hope you don't want whatever is on the highest shelf of the pantry for dinner, because it's not happening. Tall friends of the world, you don't know how lucky you are. If you have the advantage of height, take a minute today to appreciate it! Look around you and notice all the wonderful things you can see from your vantage point. And while you're at it, look around to see if there's a short person near you who might need a hand.

BUJO BORDERS AND LINE DESIGNS

Borders and line designs are actually very simple to create; they're typically just a combination of skills you already know. Let's take a look at five ideas you can use in any journal or lettering design. We'll learn the basics for each one as well as how to create your own variations.

HEARTS AND DOTS

This border is exactly what it sounds like: a combination of hearts and dots. All you have to do is draw a straight line (you can use a ruler or other straightedge to help you), then draw a series of alternating hearts and small circles along it. You can stick with black and white, or you can add a pop of color to some or all of the shapes. I sketched mine in pencil first, then traced it with marker to make sure my line was straight and that it wasn't visible going through my pink hearts.

LITTLE LOOPS

To draw this border, all you have to do is move your pen across the page in a series of loops. To keep them relatively straight, it's a good idea to lightly sketch a pencil line using a ruler or other straightedge, then draw your loops on top. You can make the loops as large or as small as you like, and you can also play around with how close together they are. In the examples below, mine point upward like "I"s, but you can also draw them pointing downward for a totally different effect. Another variation is to color in the loops with your favorite markers.

ALTERNATING LOOPS

Once you've mastered the art of loops, you can take it to the next level by alternating which direction they point. Again, you'll want to begin by lightly sketching a straight line in pencil as a guide. Then, I like to start with an upward loop. As I bring my pen down, instead of going back up right away, I form a loop going in the opposite direction. Continue along the line alternating your loops until you reach the end of your border. Some variations are to add little dots or other shapes in the spaces between your loops, or to fill in the loops with color.

COLORFUL ACCENTS

This border is made up of short horizontal lines alternating with little decorative accents. To draw it, you'll sketch a straight pencil line first, then at the beginning, draw three little upside-down teardrop shapes. Next, trace a short portion of the straight line. Stop and draw three more teardrops, then trace another section of line. Don't worry about making each line segment exactly the same length, just try to make them look similar. Remember, the idea is that we're doing all this by hand, so tiny imperfections actually help us achieve the look we want. Continue this alternating pattern until you reach the end of your line. To finish, go back and color in the shapes. A variation on this border is to use different accents or shapes, like stars, hearts, swirls or anything else you like.

FLOWERS AND LEAVES

Floral borders and vines are a great complement to just about any design. One simple border idea is to draw a small flower in the center (you can use a basic shape like the one below or any of the kinds we learned on page 26), then extend a wavy line or flourish from each side. Draw leaves along the lines, then color them in for a pretty, natural border. Another leafy border idea is to draw a straight pencil line and sketch little leaf shapes along it. Trace just the leaves with marker and color them in, then erase the center line for an interesting effect. This looks great at the top of a page or as a divider between parts of a quote.

Take some time to experiment with these different border styles, and don't forget to explore your own ideas, too! Let your creativity go wild as you try variations on my examples and even come up with your own brand-new ideas.

Then, let's get to work using your favorite border to accent this quote. Our layout this time is very simple: three horizontal lines, followed by a space for our floral line, then three more horizontal lines.

Pencil your words onto the lines using Minimalist Print (page 14), Faux Calligraphy/Brush Technique (page 10/page 98) and Highlighted Letters (page 45) like I did, or use your own font choices instead. Then, sketch whatever border you like in between the two halves of the quote. Trace over everything with marker and fill in the border with color to finish up your creation!

GROWN-UP LUNCHABLES

Drawing Your Favorite Foods

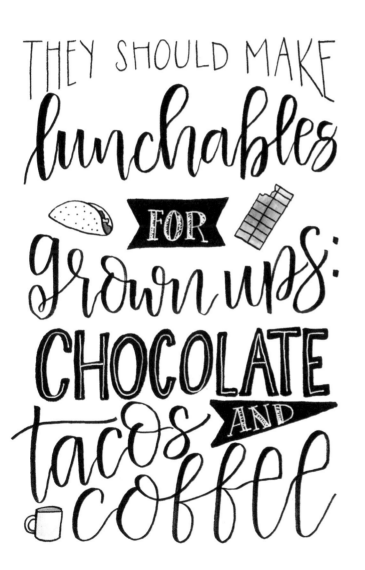

Food. We can't live without it, and who would want to anyway? In fact, thinking about what I'm going to eat when I get up is sometimes what gets me out of bed in the morning! Food also has a way of bringing people together. We share meals with our friends and families, and eating plays a role in most social gatherings. Because food is such a big (and essential) part of our lives, it only makes sense, then, that it's something we'd include in some of our artwork, too. I'm sure you've already noticed in previous chapters that food-themed quotes are fun to letter; now we're going to look at how to embellish them with some doodles that are almost edible . . . but not quite. Don't try to eat the page, okay? You're going to need it.

"THEY SHOULD MAKE LUNCHABLES FOR GROWN-UPS: CHOCOLATE, TACOS AND COFFEE."

When I was in middle school, I used to pack bologna and cheese Lunchables every single day. Side note: did you know that if you give it a little toss, that bologna will actually stick to a cafeteria wall? I, um, heard a rumor that it will actually stick there for a whole lunch period. I loved those lunches back then, but now that I'm a little older, I find myself wishing there were a grown-up version that catered to my adult tastes. For starters, how about a few tacos, a fudgy brownie and then some coffee to wash it down. Wouldn't that be perfection? Then maybe another one that has pizza and cupcakes with coffee. There are so many great possibilities. This could revolutionize lunchtime for adults, am I right? Let's get started on it, Oscar Mayer!

DRAWING YOUR FAVORITE FOODS

In honor of our quote, it only makes sense that we learn to draw chocolate and tacos, right? We already learned how to draw several types of coffee doodles (page 58), so when we put them together with our new food sketches, we'll have everything we need to illustrate our design. You'll want a pencil, a good eraser and a fine-tip, non-water-based black marker to get started. If you want to color in your illustrations, go ahead and grab your colored markers, too.

TACOS

Although there are various types of tacos, the one we're going to draw has a hard shell. So, our first step is to draw a curving line that represents the top of that shell. On one end, continue the line to make a "u" shape and connect it back up to the top of the shell. Now, draw a horizontal line for the base of the taco.

Add some dots to the outside of the shell for detail. Then, inside the taco, add color to represent meat, lettuce, tomato, cheese or anything else you like. Don't worry about distinctive shapes; it'll be obvious what you're trying to show. I like to use the No-Paint Watercolor Technique (page 30) to color in my illustrations, but you can use markers or colored pencils instead if that's what you have on hand.

CHOCOLATE

Drawing a chocolate bar is actually quite easy to do, because it's just a big rectangle made up of a bunch of smaller ones. If you're concerned about perfectly straight lines, you can use a straightedge to help you, but remember, it's okay if your drawings are imperfect because they're meant to look handmade.

If you like, you can draw a few of the pieces broken off, or even a bite taken out for good measure.

Now, what if chocolate and tacos aren't your favorite food obsessions? Never fear! You can feel free to substitute your own indulgences instead. Here are a few quick drawings of some other tasty treats I happen to enjoy, and I bet you do, too. You can easily sketch soda in a to-go cup that's much like our coffee cup (page 58), but with a straw. A donut is nothing more than a circle in a circle, and an ice cream cone is a combination of basic shapes, too. French fries are just rectangles in a square-ish container, and so on. Feel free to copy, trace and recreate any of these illustrations that apply to your own ideal Lunchable.

Go ahead and try your hand at these illustrations . . . if you're anything like me, you'll have more fun drawing food than actually making it. Plus, you can enjoy that it's calorie-free. Then, let's put everything together as we head to the border page for our design.

Here's the layout grid we'll be using to organize our quote.

We're using a combination of four of our fonts this time: Minimalist Print (page 14), Faux Calligraphy/Brush Technique (page 10/page 98), Highlighted Letters (page 45) and the Chalkboard Effect (page 93). We're also making use of banners for our small words (page 49). Finally, we'll be filling in the white space with three very appropriate doodles: the tacos and chocolate we just learned, and coffee (page 58). As always, you'll want to work in pencil first, then move to tracing with marker and finally add color to the illustrations with the No-Paint Watercolor Technique (page 30). When we put all our skills together like this, we're sure to create a tasty and hilarious masterpiece!

PRACTICE BELOW

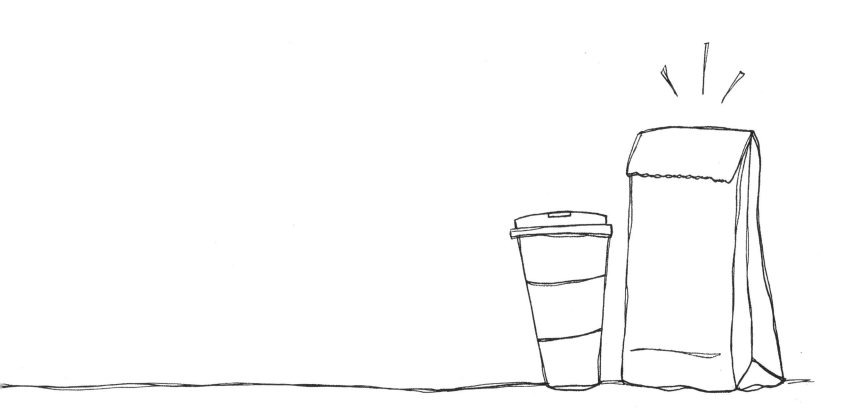

THE BEST FIVE MINUTES
Creating Shaped Designs

As we learned the basics and the not-so-basics of interesting composition, we looked at how different shapes can work together within a design. Arches, triangles, rectangles, diagonals and more can be combined to give the words in our quotes shape and dimension. But there's another way that shape can impact our designs as well; we can place an entire quote inside any given shape and let it take on that form. A circle is the simplest shape to start with, but it doesn't stop there. You can shape your design like just about anything you can imagine. This is a great way to visually reinforce the meaning of a phrase; for example, a quote about cats can be written in the shape of the animal's silhouette. In this chapter, we'll learn the basic steps to shaping a design so that you can create anything you like. Find yourself a sharp pencil, a black marker and a really good eraser, and we'll be ready to tackle this new design challenge!

"HAVING ALL OF THE LAUNDRY DONE IS THE BEST FIVE MINUTES OF THE WEEK."

Friends, I have come to an unpleasant but inevitable conclusion. There is no such thing as being caught up on laundry. It's a trap. You see, just when you think you've reached the light at the end of the tunnel, you remember that everybody is wearing something today. You might have cleaned every last thing in the pile, but in about five minutes, today's outfits will become tomorrow's dirty clothes. We're fighting a losing battle. The washing machine and dryer might look harmless, but they're really unbeatable opponents in the war on laundry. Friend, if you ever find yourself in the position of having even the vast majority of your home's laundry clean, I salute you. And I also want you to come wash mine.

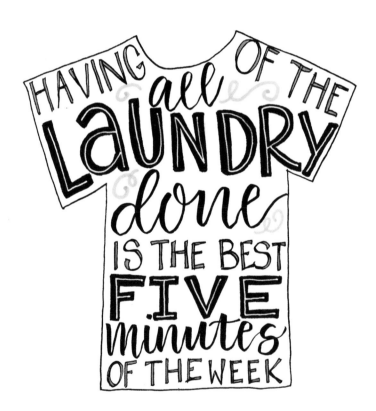

CREATING SHAPED DESIGNS

It's time to get in shape! Literally! We're going to be putting our lettering inside a specific shape to help visually reinforce the meaning of our quote. In this chapter, we'll be practicing one shape in particular that we can use for our featured saying, but the sky's the limit when it comes to shaping your designs. Take this idea and run with it using all kinds of different shapes for your future artistic creations.

STEP 1

Decide on the shape itself.

Do you want something simple and geometric, or are you hoping to create something more complex that ties in to the words in your quote? Today, our featured quote is talking about laundry, so it makes sense to use a shape related to that topic, like a T-shirt or a laundry basket.

STEP 2

The next step is to lightly sketch an outline with your pencil.

Don't worry about perfection; we just want a general guide. You can use a straightedge if you like, or trace something you have on hand. Coffee mugs make great circles, and there are lots of things around the house that will work for some of the other shapes you might want. If you're going with something like an animal silhouette and don't feel confident drawing it, you can print out an image and trace the outline onto your paper.

STEP 3

Once your outline is sketched, it's time to position the words inside.

In order for the shape to be easily identified, you'll want to make sure your words and embellishments take up most of the open space inside the outline. You can choose any combination of your favorite fonts and embellishments. As always, think about making the most important words larger for emphasis, like I did with "laundry" and "five." To make the phrase really fit into the space provided, you'll want to curve certain words to reflect the shape, as I did with the ones at the neck of the T-shirt.

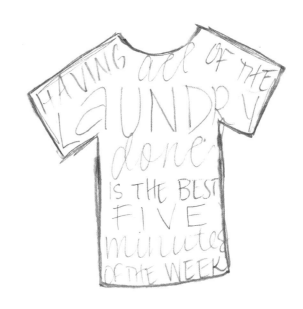

STEP 4

Trace over your words in pen and/or marker and erase any remaining pencil lines.

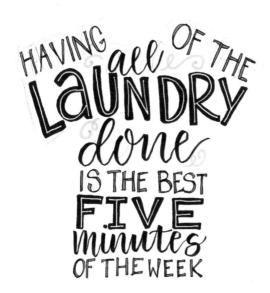

It's totally your choice whether to use the marker to trace the outline as well or whether to erase it and let the words stand alone.

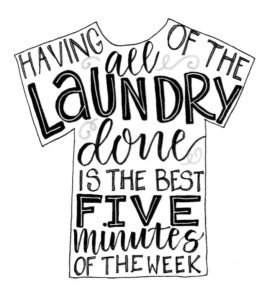

It's that simple! You can complete this basic process for just about any shape, and you'll end up with a unique design that visually reinforces the meaning of your quote.

To recreate this humorous design, you'll be pulling together several of our fonts within the shape of a simple T-shirt. I used a combination of the Double Trace Font (page 63), Brush Technique (page 98) and Highlighted Letters (page 45) for my words. Then, I colored in the open spaces of the Double Trace Letters and added a few small loop and swirl embellishments to fill in the empty white spaces inside the shirt shape. Now it's your turn! Use the practice space below to try sketching out the quote, then create your own version on the border page.

PRACTICE BELOW

MISSING MEMORY

Advanced Wreaths

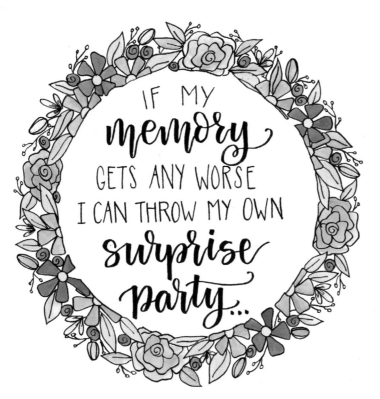

Basically, negative space refers to the part of an image that's left without color or illustration. We're going to draw our flowers and foliage in such a way that we're left with a perfect white circle in the center where we can letter a quote. This is a powerful visual effect, and I think you're going to love how it turns out. Take a look.

"IF MY MEMORY GETS ANY WORSE, I CAN THROW MY OWN SURPRISE PARTY..."

The other day, we were coming home from an appointment and I kept on driving right past our road. To be fair, we were entering the development from a back entrance because we were trying to avoid roadwork on Main Street, but still. I do know where our house is. Shaking my head, I found a spot to turn around, only to have my older son remind me that we weren't, in fact, supposed to be heading straight home anyway. I had promised him McDonald's. Turning around again, I drove to McDonald's and then right on past it as if I were going to the grocery store instead. True story! Eventually, I got my act together and we found our way to the drive-through and then back home, thank goodness. The older I get, though, the more I forget. I can quote episodes of *Full House*, but I can't remember the name of my cousin's newest baby. I can remember all the lyrics to the songs that were popular in 1989, but darn if I can remember why I walked into the kitchen. Oh, well. At least while I'm here I might as well have a snack.

In chapter 22 (page 103), we learned the art of creating wreath embellishments by sketching a circle and drawing all kinds of plants and flowers around it. Now, we're going to take that idea one step further to create a slightly different and more advanced effect. This time, we're going to use both complete and partial botanical illustrations to create a shaped area for our design made of negative space.

ADVANCED WREATHS

When creating your advanced wreath, you can use any combination of flower, leaf and plant illustrations we've learned so far. You can also use other types of drawings, too, including your own flowers or even something totally different, such as food or animals. I'll be using all of our fancy florals along with a variety of leaves for my example wreath.

STEP 1

Trace or sketch the shape you want to remain white in the center.

Here, I'm using a circle, but you can also use a square, rectangle or other shape instead.

STEP 2

Begin sketching your botanical images around the circle.

I like to do a light pencil sketch first, so that I have an idea of where my flowers are positioned. You can see that I don't worry about perfection or details, just general shapes to serve as a guide for where my flowers will go. Let your flowers overlap the center shape.

STEP 3

Go back with an eraser and remove any parts of your flowers and leaves that are on the inside of the circle.

STEP 4

Trace over the illustrations with a fine-tip black marker.

I like to use the Tombow Mono Drawing Pen or Sakura Micron. Erase any pencil marks you can see. If there are any blank spaces remaining, you can fill them in with tiny details like budding branches or rosebuds.

STEP 5

Color in your illustrations using the No-Paint Watercolor Technique (page 30) or any other supplies you have on hand.

This will leave you with a beautiful, colorful frame for your hand lettering.

Once your wreath is finished, it's ready to be a frame for your lettered quote; just sketch your words inside with a pencil first, then trace over them with a marker when you're happy with the placement. Erase your pencil lines, and you'll be left with a complete design.

There are lots of variations you can do on this basic idea, too, like making a seasonal wreath or even a funky wreath made out of something like food! Check out the example below—the perfect border for a quote about desserts!

For this chapter's quote, because the wreath is so colorful and ornate, we'll be keeping our lettering simple inside. You'll want to sketch six horizontal guidelines, one for each line of text, then pencil your words in place using a mixture of Minimalist Print (page 14) and Faux Calligraphy (page 10).

Go over the lettering with markers, and your masterpiece is ready to display or share with a friend!

PRACTICE BELOW

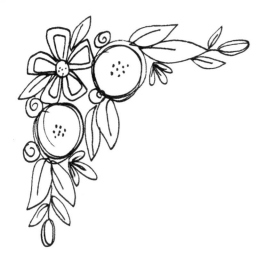
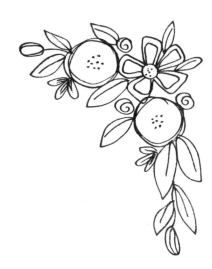
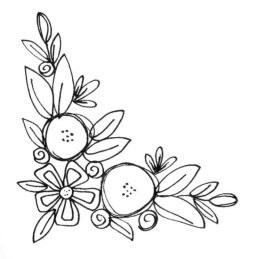

I'M A RUNNER

Simple Stippling

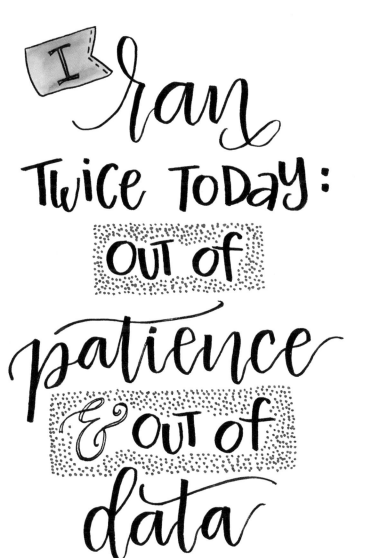

By now, you've learned that you can fill blank space in a design with letters, flourishes or color. In this chapter, I want to show you another method you can use that creates a really powerful visual effect without much effort at all . . . just my kind of technique! It's called stippling, and it's the process of painting, engraving or drawing with dots. You can achieve all kinds of shading and shadows just by changing how large your dots are and how close they are to one another. There are plenty of ways to incorporate this technique into your lettered art, including my favorite, which is to use the dots around letters to help emphasize them. You can stipple with pretty much any type of pencil, pen or marker, but a sturdy tip is going to be helpful. So, grab your favorite bullet-tip marker and let's get going!

"I RAN TWICE TODAY: OUT OF PATIENCE & OUT OF DATA."

In the event that you ever see me running, you better start running too, because there's a bear or possibly a zombie behind me. In every other situation, I will be walking. Where are my fellow non-runners? I know you feel me here. Unless it's a "fight or flight" scenario, people like us know that running is really just a cruel form of torture. In any given day, I run out of patience, run out of coffee and run out of excuses. (I no longer run out of data because I went over my limit so often that my husband gave in and changed my plan.) That is quite a lot of "running," and it makes me tired, so I need a rest. For all the runners of the world, I'll be sitting over here cheering you on.

SIMPLE STIPPLING

Truth be told, there are some techniques in the art world that are a little bit tricky. Stippling, however, isn't one of them. Literally, if you can touch the tip of a marker to your paper, you can do it! All you have to do to create a stippled effect is gently tap your marker repeatedly to create a series of dots. You can make them as close together or as far apart as you like. The closer they are, the more of a solid colored appearance they will have from a distance.

In contrast, dots that are more spread out will look like confetti.

You can play around with creating different effects by changing colors as you go, or by changing the spacing between dots.

So how do we use it in a design? Stippling is a great way to create interesting shadowing around your letters and make them seem to pop off the page. Take a look! You can even create the appearance of letters without drawing them!

 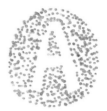

Another way to incorporate stippling into your art is to use it as a way to partially fill block letters with color. Start out with your dots very close together, then gradually separate them as you continue up toward the top of the letter.

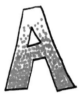

Take some time to try these different stippling effects in the practice space. Experiment with different marker types and colors so you get a feel for what you like best. Then, let's work on creating our quote design!

Because we're focusing on the stippled effect for this phrase, we're going to keep the layout very basic. Start with this simple grid layout.

PRACTICE BELOW

Then, pencil in your words using a combination of your favorite fonts: I chose Faux Calligraphy/Brush Technique (page 10/page 98) and the All Mixed Up Font (page 114). I also added a little banner (page 49) for the word "I." When you're satisfied with the letter positions, go back and do your lettering with marker, then erase the pencil lines. Finally, it's time to stipple! I chose to use stippling to highlight the two spots in the quote that say "out of." You can do the same, or you can choose to place your dots around a different part of the phrase. Don't forget to add some color to your banner, too. Then you'll have a finished piece of art!

DIRT, POOP OR CHOCOLATE
All Filled In Font

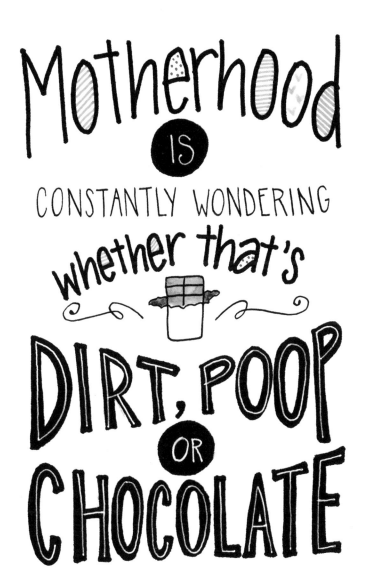

Patterns of all kinds help add visual interest to a piece of art. Often, we use them in borders or illustrations, but today we're going to incorporate them into our letters themselves. I'll give you some examples to get you started, along with a sample alphabet, but feel free to take this basic idea and let your imagination run wild. Because we will want to show some intricate detail, I recommend using a very fine-tip marker or pen for this font, like a Sakura Micron Pen or a Tombow Mono Drawing Pen, size 01 or 03. If you don't have one on hand, any fine- or medium-tip marker will do. Got one? Let's put it to work!

"MOTHERHOOD IS CONSTANTLY WONDERING WHETHER THAT'S DIRT, POOP OR CHOCOLATE."

There are many beautiful mysteries that come with motherhood (or fatherhood, for that matter). First, I was unable to fathom the overwhelming unconditional love I felt the moment my son was born. Then, I wasn't sure how I could possibly love two children equally without taking any love away from the first, but it happened. There are other mysteries, though, that aren't the least bit beautiful. From the time a child is about one year old until he or she leaves the house, you'll look at every brown stain and wonder, "Is that dirt, poop or chocolate?" You may have your own method to help determine which substance you're dealing with. Most of the time the sniff test works like a charm . . . two out of the three typically have a pretty distinctive scent, but sometimes I can't be sure. There are other "fun" mysteries too, like "What's that smell in the car," and "Who just farted?" The joys of parenthood never end.

ALL FILLED IN FONT

Remember how in chapter 27 (page 130) we added color to the enclosed spaces within our lettering? Today, we're going to be looking at those same spaces, but rather than filling them with a solid color, we'll be working with a variety of patterns. Let's start by identifying some of the types of patterns you can create.

POLKA DOTS

These can be large or small, filled in close together or more loosely and drawn in any color you like. You can even draw circles with your black fine-tip pen and color them in with a marker.

STRIPES

Whether they're vertical, horizontal or diagonal, stripes always add an interesting effect. You can also experiment with the spacing between your lines to get different looks.

GRIDS

This pattern is just like creating stripes, except that you'll do it in two directions instead of just one! Again, changing the spacing makes your pattern look totally different.

TINY SHAPES

Stars, hearts or any other tiny shapes can become a pattern if you repeat them over and over inside the space.

When I write a word in this font, I typically like to stay consistent and use the same pattern in all of the letters. However, you can also mix things up and use a variety of patterns instead.

Here's a look at a whole sample alphabet written this way. Feel free to use it for reference and inspiration, but don't let it limit you. Think about what other unique patterns you can create! I typically use a print alphabet for this, but you can feel free to add patterns to your script as well. In chapter 27 (page 130), you can see where the fill spaces are for a script font; just add your favorite pattern instead of, or in addition to, color.

AaBbCcDdEeFfGgHh
IiJjKkLlMmNnOoPp
QqRrSsTtUuVvWwXx
YyZz 0123456789

Take some time to try out these ideas, as well as some of your own, in the practice space. Then we'll move on to creating the featured quote on the border page.

Here's a look at the composition grid I used for the sample design.

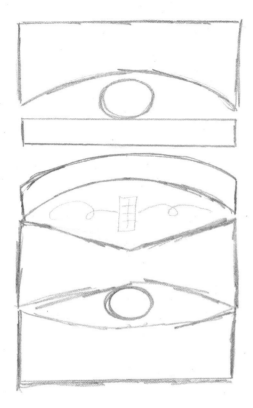

We'll be using three different fonts: Highlighted Letters (page 45), Minimalist Print (page 14) and our new one, All Filled In! You'll also recognize the chocolate bar illustration we learned in chapter 29 (page 139). After you've sketched the grid, fill in the words and trace them with marker. The final step will be adding patterns to the letters in the All Filled In Font. Use whatever colors and patterns you like to make the design your own. As always, feel free to make changes to any of the styles, fonts and illustrations as you create your own masterpiece.

GETTING TALLER

Swirls and Hearts Font

losing weight isn't working, so I'm focusing on GETTING TALLER

In my humble opinion, there's no such thing as learning too many fonts when you're a hand lettering artist. The more you know, the more choices you have any time you sit down to letter a phrase. More choices means more creativity, and the odds of finding the perfect look for your piece get better all the time. It's time to add a new font to your collection, this time a print one that incorporates swirls and hearts for a whimsical, feminine feel.

"LOSING WEIGHT ISN'T WORKING, SO I'M FOCUSING ON GETTING TALLER."

Friends, it is so incredibly unfair how hard it is to lose weight, am I right? Even when I am incredibly disciplined, it seems like the pounds come off slower than a snail crawling through molasses. What is that about? I could easily gain five pounds in twenty-four hours if I tried, but losing five pounds takes forever. There has to be a better way, yes? I feel like I should be able to stretch like those little sticky toys you get from the vending machines at the grocery store. Just grab my head and feet and pull, and I'll get taller, then I'll magically be thinner, too! It's a win-win. I'll have to buy all new clothes, but that's a sacrifice I'm willing to make. Wait, what do you mean my plan won't work?

SWIRLS AND HEARTS FONT

The base of this font is a simple monoline alphabet created with a fine-tip marker. What makes it fun is that everywhere there's a circle, rather than leaving it open, we're going to create a swirl instead. Take a look at the letter "a." Instead of forming it like we normally would, we'll keep our marker on the paper and move our hand in a circular motion to create a spiral. I like to make the spiral part of the letter slightly wider than I would in a normal font just to emphasize the swirls.

a a

The same thing goes for letters like "p," "d," "b" and "g."

apd bg

That takes care of the swirls; now it's time to talk about the hearts. We're going to channel our elementary-school selves and use tiny hearts to dot our "i"s as well as anywhere else a dot or period would normally go.

Here is a look at the entire alphabet written in this font.

abcdefghijklm
nopqrstuvwxyz
0123456789

Isn't it cute? Have fun playing around with it in the practice space, and remember, it's supposed to look hand-drawn, not digitally perfect. It's okay if some hearts are larger than others and if one swirl is a little tighter than the one next to it. Just enjoy the process, then when you're ready, we'll apply this along with some of our other fonts and skills to make the featured quote design.

We're going to keep the layout simple this time; everything is based on straight baselines, as you can see in the grid below.

Pencil in your words, using a mixture of Faux Calligraphy/Brush Technique (page 10/page 98), Minimalist Print (page 14) and our new Swirls and Hearts Font. Trace your lettering with marker; I used the thin end of a Tombow Dual Brush Pen for "getting taller" to really help it stand out in addition to making those letters the largest ones in the design. Finally, I added the looping borders from chapter 28 (page 134) straight across the top and bottom and colored them in with shades of blue, green and yellow.

PRACTICE BELOW

A GIRL'S BEST FRIEND

Gems and Geometric Shapes

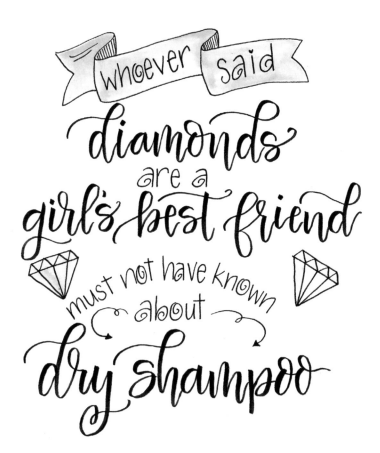

There's just something about a diamond, am I right? I love to sparkle and I'm all about gems, both in my wardrobe and in my artwork. Gems and other three-dimensional geometric shapes can add color and depth to a lettered piece, really making it stand out. In this chapter, we'll learn how to draw a few of these basic shapes, then we'll be using one to accent a quote that you get to help create. Let's pull out a pencil and a good straightedge like a small ruler and we'll get started.

"WHOEVER SAID DIAMONDS ARE A GIRL'S BEST FRIEND MUST NOT HAVE KNOWN ABOUT _____"

In 1949, a man named Leo Robin wrote the lyrics to a song called "Diamonds Are a Girl's Best Friend." Since then, the phrase has become part of pop culture, and while it's certainly true that many of us enjoy a good piece of sparkling jewelry, I think it's time we reevaluated the statement. Here's the thing. I can think of at least ten things off the top of my head that I would rather be given than a diamond. Want to hear them? Iced coffee, pizza, a shopping spree at Target, a million dollars, a live-in maid, the newest iPhone, an all-expenses-paid vacation, a personal chef, a night without my kids and a pedicure. It's not really Leo's fault—I mean, Target and smartphones and things women really need like dry shampoo weren't even invented in 1949. He couldn't have known. But today, it's time to revamp that statement and make it our own. This time, YOU are going to fill in the blank. What is it you really love most that good old Leo didn't know was better than a diamond?

GEMS AND GEOMETRIC SHAPES

I have to confess that these particular embellishments are probably the least natural and comfortable for me to draw, probably because they remind me way too much of geometry. However, they can be useful and very pretty accents for our lettering, so we're going to ignore the math class flashbacks and turn them into art. We're going to look at three basic gem shapes: the diamond, the crystal and the emerald.

THE DIAMOND

The basic diamond is probably the most universally recognized look for a gem, so we'll use that as our starting point. To sketch this shape, we'll start with a basic trapezoid. In case it's been as long for you as it has for me since geometry class, that means we draw two parallel horizontal lines where the top line is shorter than the bottom one, then connect the ends.

Next, we draw a triangle below our trapezoid. Inside the trapezoid, we're going to draw a zigzag that divides the shape into small triangles. Finally, draw straight lines from the bottom point of the gem to the spots where your small triangles touch the base of the trapezoid.

All that's left to do is color it in! Remember, gems come in all colors, so feel free to choose your favorites; don't limit yourself to the idea that diamonds are colorless.

That's all there is to it! For a slightly different look, rather than dividing your trapezoid into triangles, you can draw a series of short lines like the ones in the example below. Then, draw a straight line connecting each one to the base of the gem. Both of these variations resemble diamonds, just cut in different ways.

THE CRYSTAL

Crystals come in several shapes. We'll start by looking at one that is pointed on both ends and wider in the center.

Start by drawing a shape that resembles a kite. Across the center of the shape, draw a line that is horizontal in the center and diagonal on each side, as shown below. Connect the spots where the line bends to the upper and lower points of the shape.

Color it in and your crystal is complete!

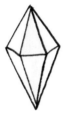

Here are a couple of other crystal shapes drawn with the same basic technique. All you have to do is change the original shape you sketch, then the rest of the steps are the same.

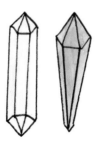

THE EMERALD

To draw an emerald, you'll begin with the outline: a shape that looks like a rectangle with the corners cut off. Draw a smaller version of the same shape inside the larger one. Connect the two shapes with short, straight lines in the corners.

 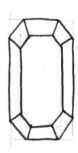

Despite the name of this shape, any gem can be cut in this fashion, so you can color it in however you like.

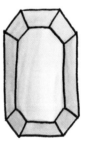

Whew, that's a lot of sparkly gems, right? Spend some time sketching them in the practice space. Then, it's time to work on lettering and illustrating our quote! Remember, you get to fill in the blank this time. I used "dry shampoo," but you can substitute anything that comes to mind and relates to your life. Here's a peek at the composition grid we're using: a double folded banner (page 49), a rectangle, a horizontal line, a rectangle, an arch and one more rectangle.

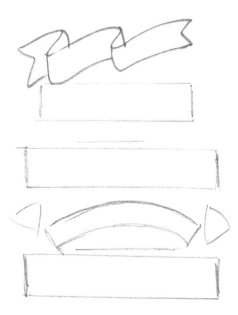

We'll be filling in our gems on either side of the arching words. As always, do your pre-lettering work in pencil, then trace with marker when you feel confident of positioning. I used a mix of the Swirls and Hearts Font (page 162) and Faux Calligraphy (page 10), but you can switch and use any of our other fonts, too. The final step is to add a bit of color to the banner and the gem illustrations. Then your artwork is complete!

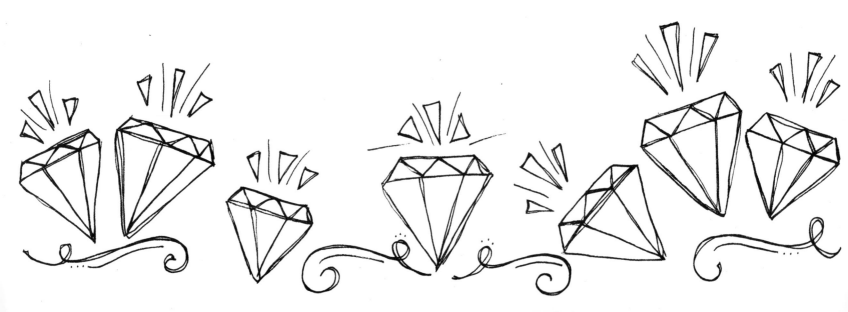

LIKE A MILLION BUCKS

Creating Corner Embellishments

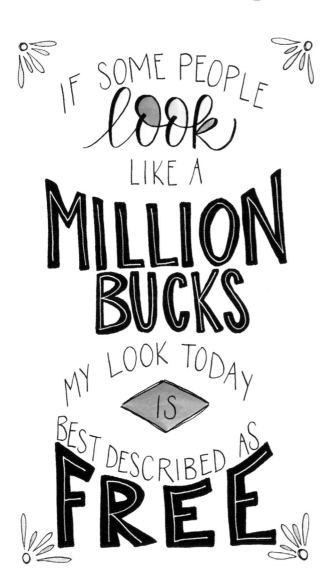

It may be true that "nobody puts Baby in the corner," but putting *something* in the corner can be a great way to add interest to your artwork. There are tons of options when it comes to corner embellishments, so there's no way to go over all of them in just one chapter, but we're going to take a look at a few of my favorites to get you started. Then, once you've gotten the hang of it, you can experiment and try some other designs of your own. You may end up with something to teach me!

"IF SOME PEOPLE LOOK LIKE A MILLION BUCKS, MY LOOK TODAY IS BEST DESCRIBED AS FREE."

My closet is full of nice clothes, and I am well aware of how to style my hair and apply makeup. I just didn't bother with any of that today. Chances are pretty good that I won't tomorrow either. It takes a ridiculous amount of time and effort to wash my hair, blow-dry it and then try to make it curl. If I'm going to do all that plus full makeup, I have to wake up a whole hour earlier, which we all know just isn't happening. I mean, who set these standards after all? I think a messy ponytail, yoga pants and a tank top should be the new standard of beauty, don't you? It would save us time and money and all kinds of aggravation. Plus, then you can think I went to the gym instead of just rolling out of bed. It's a win-win!

CREATING CORNER EMBELLISHMENTS

In this chapter, I want to share with you eleven different embellishments that are perfect for the corners of your designs. Many of them start off in similar ways, so I've divided them into four different groups. As you look at them and try your hand at drawing them yourself, you'll see how easy it is to take a basic design concept and change or add just a few details to create a totally different effect. Use these as a starting point, then let your own creativity take over as you come up with your own variations. The instructions below will show you how to create a corner shape that's perfect for the bottom left of a design. To draw the other three corners, you can either draw the shape in the other three directions or simply turn your paper each time so you can always draw it the same way.

LACY CORNERS

All three of these embellishments start by drawing an "L" shape with two lines that are equal in length. For the first variation, you'll finish by simply drawing a series of curving lines that start and end on the outside of that "L." The second variation is almost the same but leaves a little bit of space between the bottom of each "bump" and the "L" rather than touching it each time. Finally, you can take that second shape one step farther, creating a new effect by adding small circles inside each "bump."

 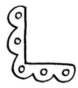

CORNER FANS

Once again, each of these images begins with a basic "L" shape. First, connect the top and bottom of the "L" with a curving line. Add a series of bumps along that line. Then, finish by drawing another curving line just below the first one. A second way to create a fan-like effect in the corner is to connect the ends of the "L" with a series of small bumps, then draw a line from the end of each one to the center of the "L." Third, you can connect the "L" with three large bumps. Draw another three-bump line just below the first one and color it in. Finally, you can embellish that third variation by adding lines from each bump to the center of the "L" and a dot or teardrop shape in the middle of each section.

 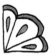

BURSTING CORNERS

To create the first design, start by drawing a small circle right where you want the corner to be. Next, draw three long, thin teardrop shapes coming out from the circle, one pointing in each direction of the corner and one pointing toward the center of the design. Finally, add two slightly smaller teardrop shapes in between the others. Color in the shapes with your favorite markers. Another variation on this idea is to start with our basic "L" shape and draw a series of other short lines coming out from the center. Try to vary the lengths of the lines. Then, draw a small circle or dot on the end of each line.

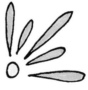 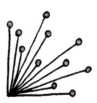

SWIRLING CORNERS

Swirls are always a pretty way to embellish a corner. One way to do this is to start by drawing two swirls, each pointing in toward the corner and slightly overlapping. Then, draw three teardrop shapes above the place where the swirls intersect, as well as one on each side of the joined swirls. Another option is to draw a looping line similar to a bracket. Then, sketch a v-shaped line crossing over it with swirls on each end. Finally, add a small flower and three dots at the bottom of the "v."

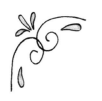

In this chapter's quote design, I used the Bursting Corners, but you can use whichever style is your personal favorite. Practice the different types in the space provided and don't forget to play around with your own ideas, too. Then, when you're ready, head on over to the border page and create your masterpiece.

This quote's composition grid looks like the sketch below. We're working with lots of arches to give our design lots of interesting shapes within itself.

Once you sketch the grid, it's time to pencil the words within those shapes using a combination of our fonts. I used Minimalist Print (page 14), Faux Calligraphy (page 10) and Highlighted Letters (page 45), but feel free to experiment with others as well. Then, pencil in your favorite corner designs. Once you're happy with the sketch, trace over your words and illustration outlines in marker. Finally, it's time to add color. I used the No-Paint Watercolor Technique (page 30) to fill in the diamond and corner illustrations, and I also used our technique from chapter 27 (page 130) by adding color to the enclosed letters of the word "look."

PRACTICE BELOW

SUCC IT UP

Sketching Succulents

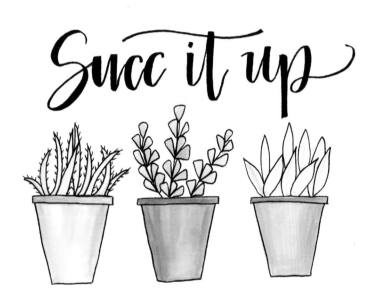

I have a black thumb. It's true. If I bring a plant into my house, it pretty much has a death sentence. I even managed to kill an African violet, which made me question my readiness for parenthood. The only thing I've ever been able to keep alive for more than a few days has been a succulent my best friend gave me in a cute little panda pot. I figure maybe the panda waters it when I'm not looking. Either way, succulents are fabulous (and hardy) little plants, and they're very much on-trend, too. Luckily for us, they are even easier to sketch than they are to keep alive. Let's take a look at a few styles today . . . I promise they don't succ.

"SUCC IT UP."

Rumor has it that succulents are impossible to kill. I'm here today to tell you that rumor is false. I can and have killed more than one. Years ago, as I was drooling over some beautiful hanging baskets at the local nursery, my husband coined a special phrase about my relationship with plants: "If you love it, you'll leave it." And he's right. If I bring it home, the poor thing has less than a week to live. I don't know whether I water them too much or too little, or whether it's something else entirely. Maybe they don't like my singing. I guess it's time to "succ it up" and realize I'm not meant to be a gardener. I'd better stick to fake plants or plants I can draw so they'll stay pretty and green forever!

SKETCHING SUCCULENTS

As with the other flowers, plants and leaves we've discussed, there are countless types of succulents in the world. While it might be fun to dedicate a whole book to them and call it *Drawing Succs*, this isn't that book. So, we're going to focus on just a few of the most popular shapes, and with slight variations you can turn them into your favorite plants. We're going to be sketching each of these succulents in a simple flowerpot, which is similar to the "to-go" coffee cup you learned in chapter 12 (page 58). To create it, you'll draw two vertical lines that are closer together at the bottoms than the tops. Connect the bottom with a horizontal line, then draw a rectangle for the rim of the pot that extends just slightly past your side lines. Feel free to add patterns and color! Now let's add some plants!

SPIKY SUCCULENTS

One common shape for succulents is a group of tall, thin leaves. The shape, width and pattern of the leaves are what will distinguish one type from another. Aloe vera leaves are pointed at the top and also have spikes along the sides. The panda plant, on the other hand, has leaves with rounded tips. The leaves are shorter than that of the aloe plant, and there are dark markings around the top edges. The snake plant has pointed leaves, but they're wider in the middle and variegated in color. Finally, the eccentric zebra plant is easy to identify by the horizontal white stripes running down every leaf. A white gel pen works perfectly to create that effect.

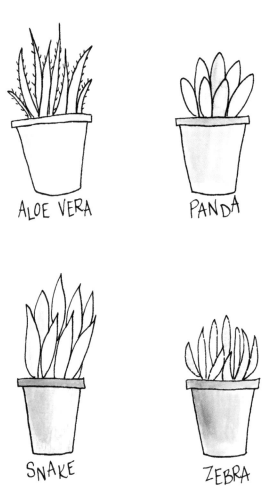

ALOE VERA

PANDA

SNAKE

ZEBRA

SHORT AND SQUAT SUCCULENTS

These are some of my favorites, because the pattern of the leaves often resembles the shape of a flower. We'll be drawing them from the side, so our focus is on the shape of the leaves: short and rounded or pointed. Hens and chicks plants have very round leaves that look much like rose petals, but with a tiny point right in the center of each one. Dudleya plants have a similar structure, but the leaves are shaped more like, well, leaves. They are pointed at the top and bottom and wider in the center. Sunburst leaves are somewhere in the middle. They are rounded with a tiny point like the hens and chicks leaves, but not as wide. Their distinguishing feature is that they're green in the center and white on the sides.

TALL AND LEAFY SUCCULENTS

The most popular of this type is the jade plant, which is like a mini tree with a trunk and branches. Each branch is full of oval leaves. Stonecrop or sedum plants also have long stems filled with leaves, but these leaves are longer and thinner than those of the jade plant. The burro's tail has long leafy branches, but unlike the other types, these branches grow downward, resembling the tail for which it is named. The leaves are very close together and are pointed on the ends.

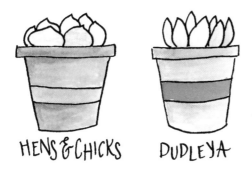

No matter which type of succulents you decide to draw, they're sure to add a lighthearted and natural touch to your designs. After practicing the various types in the space provided, choose a few of your favorites to incorporate into our fun "succ it up" quote design. This would make a great card front, and it would also be cute framed and placed on your desk at work or home.

Because we're focusing on the plants, our text itself is super simple, just the phrase written in Faux Calligraphy (page 10) or Brush Technique (page 98) using Bounce Lettering (page 17). You'll want to sketch two horizontal guidelines, one for the words and one to line up your flowerpots. Then, figure out your spacing in pencil and trace over your text and illustrations in marker. Have fun coloring in the drawings using the No-Paint Watercolor Technique (page 30).

PRACTICE BELOW

FRIDGE SQUATS

Learning to Draw Lights

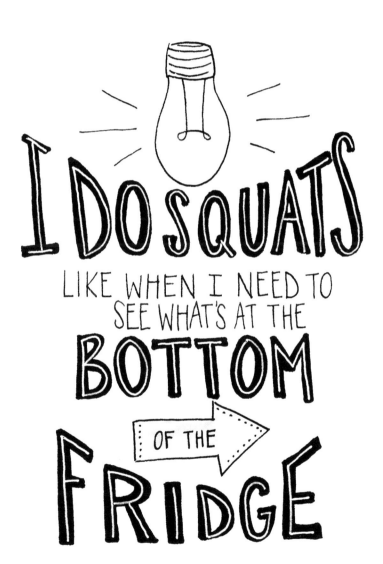

In our modern society, light is often something we take for granted. Unless the power goes out, we never have to be in the dark if we don't want to. Did you ever stop to think that we use lights both functionally and decoratively in our homes? Think about things like chandeliers, old-school lanterns and strings of bulbs in all shapes, colors and sizes. During the holidays and sometimes on summer nights, we brighten things up at night by stringing bulbs on all kinds of things, like bushes, doorways, mantels, fences and outdoor seating areas. Just as lights can decorate our homes, they can embellish our artwork, too. Today, we're going to take a look at a few ways to do just that, so choose your favorite fine-tip black marker and join me as we learn to brighten up our lettering.

"I DO SQUATS, LIKE WHEN I NEED TO SEE WHAT'S AT THE BOTTOM OF THE FRIDGE."

Exercise. It's one of those things we all know we ought to do because it's good for our bodies and even our minds but nobody ever really feels like doing it. I mean, who wants to work that hard? Plus, you get all sweaty and gross! Then, if you do push through and feel the burn, the next day everything hurts. Going to the gym is overrated. I think it makes much more sense to incorporate exercise into our daily routine, like how I do a sit-up when I get out of bed and a squat when I need to see what's at the bottom of the fridge. Carrying all the grocery bags in the house at the same time must be the same as lifting weights, don't you think? Scooping ice cream is great for the biceps . . . in fact, if you'll excuse me, I think I'm going to go exercise mine right now.

LEARNING TO DRAW LIGHTS

There are three types of lights we're going to focus on drawing in this chapter. First, we'll look at a standard light bulb, then we'll tackle strands of lights, one with round bulbs and one with the shape most of us associate with Christmas lights. Let's get started.

LIGHT BULB

The first step in drawing a light bulb is to sketch a rounded shape that's larger at the top than the bottom. This will be the bulb itself. Below the bulb, we'll draw two vertical lines connected by two curving horizontal ones to create the metal base. We'll add more curving lines for the detail, and then draw the inside of the bulb. To do this, I move my pen up, make a loop, go over, make another loop and come back down to the base.

Color in your drawing and you've got a cheerful light bulb!

STRING LIGHTS: ROUND

It's becoming more and more popular to decorate outdoor spaces and patios with large round lights strung together. To create this illustration, all we have to do is draw a line for the cord, then a small rectangle everywhere we want a bulb to go. The line can be as straight or as wavy as you like.

Now, go back and draw a circle bulb attached to each rectangle. Adding a little curved highlight line to every bulb makes them look more dimensional.

The final step is to add color. You can also add short lines coming from each bulb to indicate light.

STRING LIGHTS: POINTED OVALS

Creating "Christmas lights" is basically the exact same process, except we're going to change the shape of the bulbs. Rather than drawing circles, we're going to draw oval shapes that are pointed on the ends. I also tend to make these smaller than the circle lights.

You can place all of the bulbs on the same side of the cord, or you can randomly alternate them, which looks more realistic.

These make a great border, and they create a fun and festive look when they're colored.

Have fun trying out these different styles of lights in the practice space then let's move on to creating our featured design! Here's the composition grid we'll be using. We'll start with an upside-down light bulb in the top center, then shape our first line of text around it. Next, we have three horizontal lines of text, two small and one large. We'll add an arrow, then shape our final piece of text to mirror the first.

When you've sketched your grid, it's time to pencil in your letters and illustrations. For the sample design, I used a combination of Minimalist Print (page 14) and Highlighted Letters (page 45). Trace the words and doodle outlines with marker, then add color using the No-Paint Watercolor Technique (page 30) or any other type of coloring supplies you have on hand. Erase any remaining pencil marks and your design will be complete!

PRACTICE BELOW

CLEAN EATING

Drawing Tasty Treats

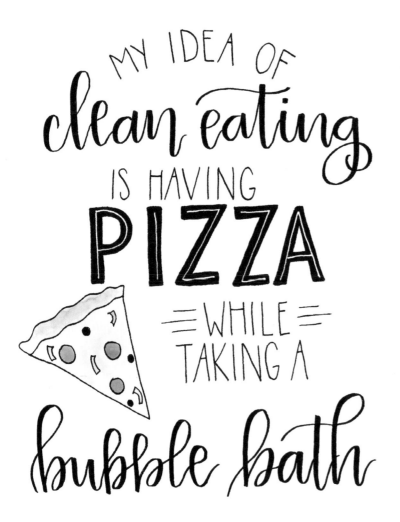

We've already discussed how essential and important food is in our lives, and why it's a good idea to be able to sketch a few edible items to go along with your lettered designs. In this chapter, we're going to add to your collection and learn to draw three of my absolute favorite tasty treats: pizza, pie and cake! Don't tell anyone, but I could literally eat pizza three meals a day . . . and may or may not have done it before. Because pizza, pie and cake are all typically round and can be sliced into triangle-shaped pieces, the drawings start out very similar. Then, we add the distinctive details that will identify exactly what delicious food we're drooling over. Why not grab yourself a slice of something yummy to snack on while you work, then let's get started! Just try not to get any crumbs on the page.

"MY IDEA OF CLEAN EATING IS HAVING PIZZA WHILE TAKING A BUBBLE BATH."

What is the deal with fad diets? When I was growing up, we learned that healthy eating meant balancing our meals using the food pyramid. I remember being told to eat lots of fruits and veggies, lots of bread and a little bit of meat and dairy. Don't eat a ton of sugar, fat and sweets. Simple enough, right? Now I'm getting conflicting messages. Don't eat bread. Eat all the bacon you want. Don't eat fruit. Eat kale. (Which, in my opinion, isn't even food.) Seriously, y'all. WHAT?! The latest thing I'm seeing is a bunch of folks announcing they're now "eating clean." I don't even know what that means. Does it mean you wash your food first? That you wash yourself before you eat the food? I'm not entirely sure, but I think tonight I'm going to give it a try. I'm ordering pizza and eating it all myself while I relax in a nice bubble bath. Clean eating. Nailed it.

DRAWING TASTY TREATS

Ready to draw? Let's start with my personal favorite food, pizza!

PIZZA

The first step to drawing a slice of pizza is to sketch an upside-down triangle shape. The lines on each side should be pretty straight, but let the top line be a little bit wavy. Draw a horizontal line to show where the cheese/sauce stops and the crust begins. Once again, this shouldn't be perfectly straight, because in real life, it's never that way.

Add shapes to represent a variety of toppings you enjoy. Circles are great for pepperoni or sausage, squares can represent ham and little curving "c" shapes can be onions or peppers. You can also play around with olives, pineapple or any other toppings your heart and taste buds desire. Color in your image, and you've got a delicious slice of happiness!

To draw a whole pizza, simply start with a circle, then draw lines to divide it into slices. From there, follow the same steps to pizza-fy it.

PIE

I've never met a pie I didn't like. And fortunately, pie is just as easy to draw as it is to eat. We'll start in the same way we did with our pizza slice, with an upside-down triangle. Once again, let the top line be wavy because it represents the edges of the crust, which are never straight.

Unlike pizza, though, pie isn't flat, so we need to give our triangle some height and dimension. We'll do this by sketching vertical lines coming from the point of the triangle and a spot close to but not quite at the top of the crust. Then we'll connect those lines together.

Finally, we'll add details, like a filling and/or slits in the crust to make it look more realistic. Feel free to add steam, a plate or anything else you like. Color it in and your pie will look ready to eat.

CAKE

Have your cake and draw it, too; simply start the same way with an upside-down triangle, although this time, we'll just round the top a bit instead of making a wavy line.

Just as you did for the pie, you'll want to draw those vertical lines to add height, then connect them. Now it's time to distinguish this drawing as cake by adding layers of icing.

Color in your design, creating any combination of cake and icing "flavors" you prefer. You can also add whipped cream, a cherry, a candle or other embellishments on top of your cake slice to make it extra festive.

We'll be making use of the pizza in our design for this chapter, but first, take some time to practice all three of these tasty treats in the space provided. Which one is your favorite?

Let's take a look at our layout for the finished lettering piece. We're going to incorporate the pizza right into the design, making a special space for it in our grid.

PRACTICE BELOW

Because the word "pizza" and our illustration are our focal points, I decided to keep the rest of the lettering simple, using Minimalist Print (page 14) and Faux Calligraphy (page 10) along with Highlighted Letters (page 45). I also used a few straight line embellishments (page 80), and of course we always want to use our ascender and descender flourishes (pages 67 and 76) and Bounce Lettering (page 17) whenever we have the chance. Once you've penciled in your letters and drawing, all that's left to do is trace with markers and add color to your slice of pizza. Which toppings will your pizza have? Let's get going—this design is making me hungry!

SLEEP HURTS

Creating Your Own Font

YOU MIGHT BE *getting old* IF YOU HURT YOURSELF WHILE YOU'RE *sleeping*

Now that you're on your way to becoming a hand lettering pro, you might be curious about how to turn your own style of writing into a font that you and others can use digitally. Personally, I dreamed of creating my own font for years, but was unsure how to go about doing it and afraid it would require a financial investment I was too cheap to make. Then, my friend Gwen (who is a talented illustrator herself at gwendegroff.com) told me about a website that allows you to create a font totally free! I realized how simple it actually was and in just a few days, I had created two separate fonts, Latta Print and Noelle Script, which are now available for sale on creativemarket.com. I want to share with you a quick step-by-step guide for how you can do the same. Whether or not you choose to sell your fonts, I think you'll enjoy being able to use them personally for your own digital projects.

"YOU MIGHT BE GETTING OLD IF YOU HURT YOURSELF WHILE YOU'RE SLEEPING."

"Oh no!" I whimpered to my husband one night last week. "I did a thing to my back." We had been relaxing after putting the kids to bed and I'd just stood up to go use the bathroom. He looked at me quizzically, asking what I had done. I stuck out my lower lip and replied, "I stood up." Yes, friends, you read that right. I injured myself by standing up. Getting older is a real kick in the pants. One day you're young and healthy and you feel like you're twenty-one, and the next thing you know, your body rebels and says, "Sit down, old lady." I'm currently trying to find the silver lining to the whole aging process and I haven't found it yet. I'm too young for meal discounts and AARP, but there's gotta be something, right? Please tell me there's something. Maybe it's that I'm old enough to eat cake for breakfast if I want to. It's a small consolation, but right now, it sounds pretty good.

CREATING YOUR OWN FONT

Before you create a font, there are two important decisions you need to make.

DIGITAL VS. PAPER

The process we're going to learn can be done in one of two ways. The easiest way is digitally. I created my letters using the Apple Pencil and the Procreate app on my iPad Pro. You could also use any other app or program that allows you to letter digitally and to save files in PDF format. If you don't have a digital option available, don't worry; you can do it by hand with paper and markers, too.

PRINT VS. SCRIPT

It is *much* easier to create a print font than a script one and it takes only a fraction of the time. I definitely recommend starting out with print first, then moving on to try script after you've gotten some experience under your belt. With a script font, you have to consider how every single letter connects to every other letter, which is incredibly tedious and time-consuming. Trust me, I know from experience!

Once you have an idea what style of lettering you want to use for your font, we're ready to move on to creating it.

STEP 1

Create a free account at www.calligraphr.com.

A free account will allow you to try this process by creating one font with 75 characters. This is how I created Latta Print. If you want to take things further and add more characters, or create more fonts, you can pay $8, which gives you access to the upgraded features for 30 days. There's no continuing monthly subscription; you simply upgrade whenever you want and renew if/when you want to.

STEP 2

Click the templates tab and choose the characters you want to include in your font.

For a free font, you'll want to select Minimal English and Minimal Numbers. This will give you the complete upper and lowercase alphabet, numerals and very basic punctuation. If you'd like a few more symbols, you can choose Minimal Punctuation as well, but you'll need to individually delete four of the characters to get down to a total of 75 (unless you pay the $8 fee).

STEP 3

Click "Download Templates."

I recommend checking the box for "Draw Helplines" because that's what helped me keep my letters straight and evenly sized.

STEP 4

Draw your letters on the templates.

If you're working digitally, open the templates in your program of choice. To get them into Procreate, I ended up actually taking screenshots of the downloaded templates and then inserting the screenshots onto a blank canvas. If you are working with a physical pen and paper, you'll want to print the templates and draw directly onto them with your favorite marker.

STEP 5

Click the "My Fonts" tab, then "New Font."

Choose a name for your font. You can edit it later, so don't stress out too much about that part. You'll also see three sliding bars. Most likely, you won't need to adjust the font size or word spacing bars, but you may want to change the letter spacing. Mine is 50 percent for Latta Print. It all depends on how close you want each letter to be to the ones before and after it. For a script font, you'll want to slide it all the way down to 1 percent to get the letters as close together as possible. You can edit the letter spacing at any time, so just choose a place to set it initially, then you can play around with it as you preview your font.

STEP 6

Upload your templates.

If you used real paper, you'll need to scan or take digital images of the templates and save them in PDF format. If you kept things digital, this part is super easy: just click on "Upload Template." If any of the letters doesn't look the way you want it to. you can click directly on it and choose "Edit Character." This will give you the ability to erase a mistake or smooth out a rough edge. If you want to redo the letter completely, just delete it, redraw the letter on a new template and upload it again.

STEP 7

Adjust your size and baselines.

To do this, click on the three dots in the menu bar and select "Adjust Baseline." Scroll through the characters, and for each one, click on the arrows or plus and minus buttons to adjust. You'll want each letter sitting on the baseline and all your letters to be equal in height.

STEP 8

Click "Build Font."

You'll get a screen like the one below where you see a preview of your characters.

Click in the box and type anything you like to test it out! Try using all caps, all lowercase and a mix of both. Write your name, your favorite food, your favorite book title *cough* and anything else you can think of. You want to make sure in this preview that the letters work together the way you want them to. If you want to make changes, you can! Just close out of the window and go back to change individual letters, letter spacing or whatever else you want to fix. Then, go back and choose "Build Font" again. You can do this as many times as you need to until you're satisfied. When you're ready, click and download the font files at the top of the screen and save them to your computer.

Once the files are saved to your computer, you can upload them to Creative Market, Etsy, Gumroad or any other site where you'd like to sell and/or share them. You can email them to a friend, save them to Google Drive . . . whatever you want to do. After the font is installed and you start using it, if you find a mistake and want to fix something, you can go back in to your calligraphr.com account and easily make changes. Fix whatever is wrong, then click "Build Font" again and save the new file.

Honestly, I was shocked by how easy this process was and the fact that it's free! I did pay the $8 upgrade because I wanted to make a second font, plus it gave me the extra options I needed to work with script.

You can see my fonts at creativemarket.com/oneartsymama and purchase them for your own personal and business use.

I created this chapter's sample design using my fonts Latta Print and Noelle Script. On the border page, I'd love for you to recreate it using your own lettering in whatever styles you like. Think about how you would form letters in your own font and experiment with writing that way as you letter the quote!

PRACTICE BELOW

PROJECT IDEAS

Whew, friends, you made it! That was a lot of learning and creating! So now what? First, I say you and I both deserve a nap. Then, it's time to talk about where to go from here. You can easily take all the things you learned over the last 40 chapters and use them to create as much gorgeous hand lettered art as you want. Fill up sketchbooks, frame your favorites and make cards for your family and friends. But that's not all. These skills transfer to all kinds of other media as well as paper. Let's chat about five non-paper surfaces you can use to create awesome lettered projects.

WOOD

When it comes to lettering on wood, the first step is to sand the surface and make it as smooth as possible. I know the rustic look is popular, but trust me, the smoother the wood, the easier it will be to letter on top.

Next, you'll want to apply a base coat of paint. Personally, I like to use chalk paint (not to be confused with chalk*board* paint) because it gives a very flat, matte finish that's good for writing on. However, you can also use acrylic or multi-surface paint instead. Once the base coat is dry, you can letter on top using either a paint marker or a permanent marker. As always, you'll want to lightly sketch your design in pencil first, then trace over it and erase any remaining pencil marks once the paint marker is completely dry.

Of course, you can always use an actual paintbrush and paint to do your lettering as well, but I personally find that a marker is much easier to control. If you do use a paintbrush, you'll want something called a liner brush, which is small and thin, rather than a thick, wide brush designed for applying a base coat.

Another totally different option is to letter on unfinished wood using a wood-burning tool. You'd pencil in your design first, then go over it with the wood-burning tool, following the directions on the package. I am really, really terrible at wood burning, so try that at your own risk; I can't help you there.

WHAT KIND OF WOOD CAN YOU USE?

Pallets, scrap wood, wood slices, cut/shaped wooden signs, laser-cut wood and furniture.

WHAT CAN YOU CREATE?

- wall art
- personalized signs
- decorated furniture
- coasters
- photo frames
- magnets
- ornaments

CHALKBOARDS

Chalkboard lettering, as we learned in chapter 20 (page 93), is an incredibly popular way to bring lettering into your home or business. You can letter on any actual chalkboard surface as well as anything that has been painted with chalkboard paint. This is a special paint you can buy that needs to be applied according to the directions on the package and "cured" by rubbing chalk over the painted surface before you letter on it. Once you do that, "real" chalk will work on these surfaces, as well as chalk markers. For a permanent design, you can use a white paint marker instead.

If you want the look of the chalkboard effect without the mess, you can simply paint any surface black and letter on it with a white paint marker or white paint and a brush. For more information about which paint and chalk markers are the best for your project, see the Supplies section on page 7.

WHAT CAN YOU CREATE?

- framed chalkboard art
- sandwich board
- hanging sign/wall art
- chalkboard wall
- centerpieces
- gift tags

FABRIC

Did you know you can apply your lettering skills to fabric? There are several ways to make that happen! First, you can easily use a fabric marker or fabric paint and a paintbrush to create your lettered design directly on the project. I recommend FolkArt Fabric Creations Fabric Ink, because it's machine washable when cured and dries incredibly soft and flexible.

There's another method that requires more supplies, but I personally love the way it turns out. You'll need an electronic cutting machine like a Cricut or Silhouette, as well as heat transfer vinyl. The first step is to convert your design to a digital image, which you can do by scanning it or taking a photo and uploading it to your device. Next, you'll open that file in the software for your cutting machine, clean it up and turn it into a cut file. Use your machine to cut the image from heat transfer vinyl, then weed it by removing all the vinyl that isn't part of the design. Finally, use an iron or a heat press to transfer the vinyl to your fabric. Once adhered, your piece will be machine washable.

WHAT CAN YOU CREATE?

- T-shirts
- pillow covers
- kitchen towels
- hats
- table runners
- socks
- decorative shoes

CANVAS AND EMBROIDERY

To letter on canvas, you'll want a paint marker or fabric paint and a thin brush. I prefer the marker because it gives me much more control and feels just like lettering with my regular markers.

There's another option for lettering on canvas too, which will appeal to those of you who enjoy needlework and embroidery. Simply sketch your design in pencil onto canvas, insert the canvas into an embroidery hoop, then use your favorite stitches to make the design come to life with your needle and thread! This is a whole new way to use lettering in your crafty projects.

WHAT CAN YOU CREATE?

- canvas wall art
- tote bag
- bookmark
- decorative Bible cover
- shoes
- embroidered wall hanging

CERAMIC AND GLASS

When you use the right supplies, you can even letter on ceramic or glass. If your piece is purely decorative, you can use multi-surface paint or permanent markers. However, if you plan to use the project regularly, like a coffee mug or other kitchen supply, you'll need to make sure you have a food-safe ceramic marker. This will ensure your safety as well as the permanence of your design as it is repeatedly used and cleaned.

Another way to letter on glass is to use a washable paint marker or chalk marker on a window to create some seasonal fun or a store's window display. You'll want to do the lettering on the inside to protect it from wet weather, which is tricky, because you'll have to write backward! Then, simply wash the design off when you're ready to remove it.

WHAT CAN YOU CREATE?

- coffee mug
- plate
- vase
- wine glass
- serving tray
- candleholder
- cookie jar
- window art

ALOE VERA PANDA SNAKE ZEBRA

ACKNOWLEDGMENTS

Dan – My love, my best friend, my constant encourager and supporter. I love you more today than yesterday, but not as much as tomorrow.

Noah – Thank you for understanding the times when Mama needed to work instead of play. Now, let's have some fun! Love you to the moon and back!

Nathan – Thank you for being patient while Mama finished her book. You are such a gift from God and I am so happy to be your Mama. *Wo ai ni.*

Mom and Dad – Your support and love mean more than I can say. Thank you for teaching me to dream big and believe I can do anything.

Will, Sarah, Meg and the Page Street team – We make a pretty great team, don't we? Thank you for making my ideas into reality for the third time. It is truly a pleasure working with you. What do you say we do it again?

Stefan Kunz – Your composition grids inspire me and changed the way I design layouts. Thanks for sharing them and your amazing talent with the lettering community. Keep on creating marvelous things!

The Lettering Community – You inspire me daily and encourage me to become better at what I do.

You, Reader – You are the reason this book exists. Your support of my work and your interest in learning to create beautiful things has made my dream of becoming an author a reality. I hope these lessons give you skills and confidence as well as a few good laughs. Keep on creating; practice makes progress!

ABOUT THE AUTHOR

Amy Latta is an artist who is passionate about inspiring others to create. She is the author of the bestselling books *Hand Lettering for Relaxation*, *Express Yourself: A Hand Lettering Workbook for Kids* and *Caligrafia para Relaxar*, as well as the award-winning blog Amylattacreations.com. Her original lettered designs have been featured nationally in GAP stores and Starbucks commercials, as well as on the covers of books written by other authors. Amy is a Maryland girl who loves spending time with her husband and two sons, and their furry friends. She also drinks copious amounts of iced coffee and enjoys helping others find the humor in everyday life.

INDEX

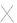